RAPHAEL

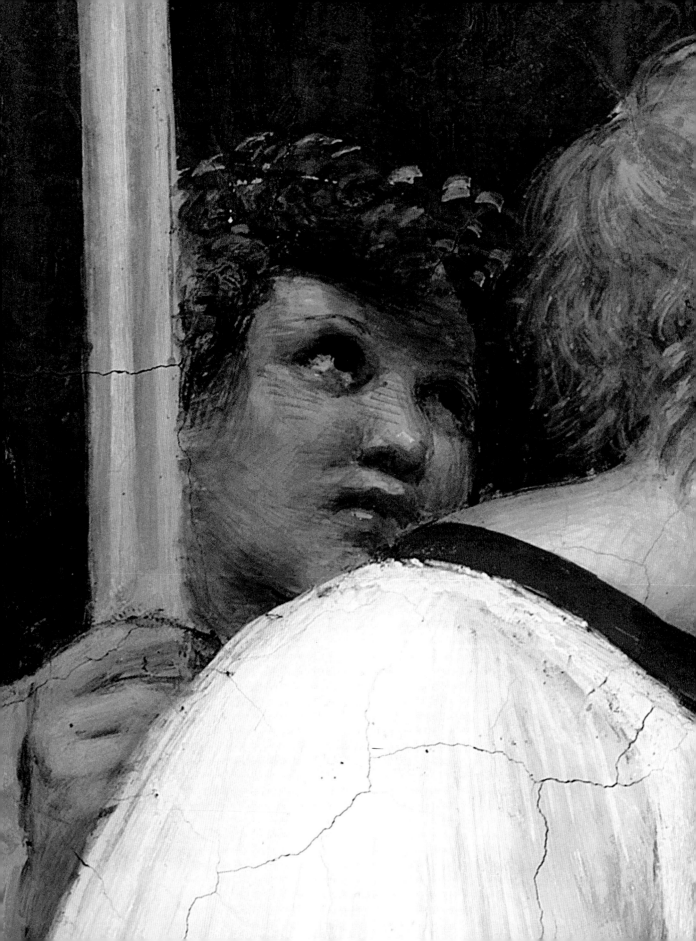

RAPHAEL

Painter and Architect
in Rome

A Guidebook

Edited by
Francesco Benelli and Silvia Ginzburg

Texts by
Barbara Agosti, Valentina Balzarotti, Francesco Benelli,
Roberto Berlini, Alessandra Caffio, Camilla Colzani,
Cristina Conti, Silvia Ginzburg, Francesca Mari,
Adele Milozzi, Serena Quagliaroli

OFFICINA
LIBRARIA

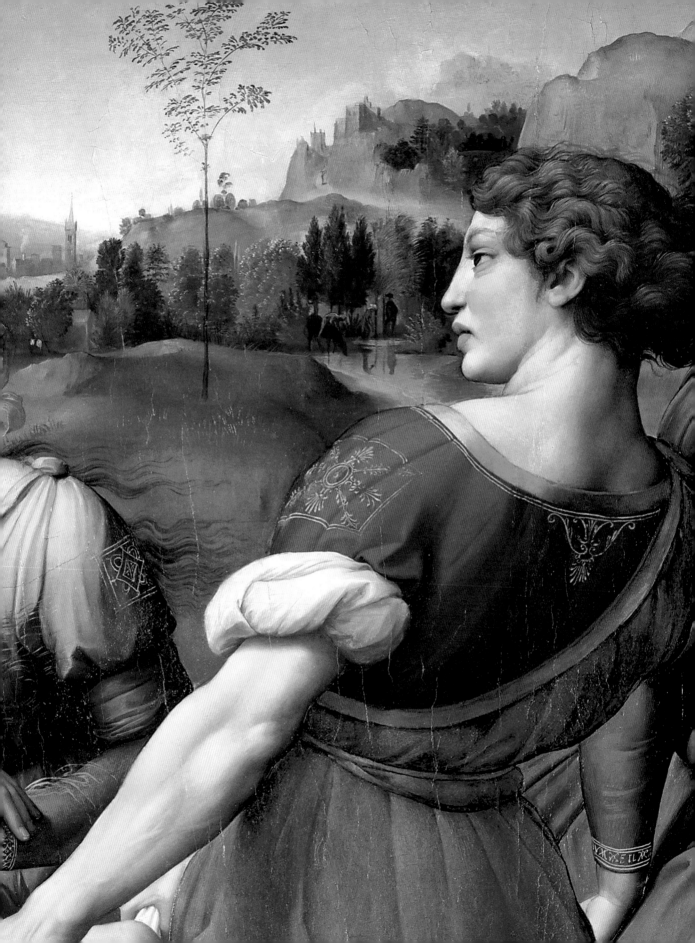

Contents

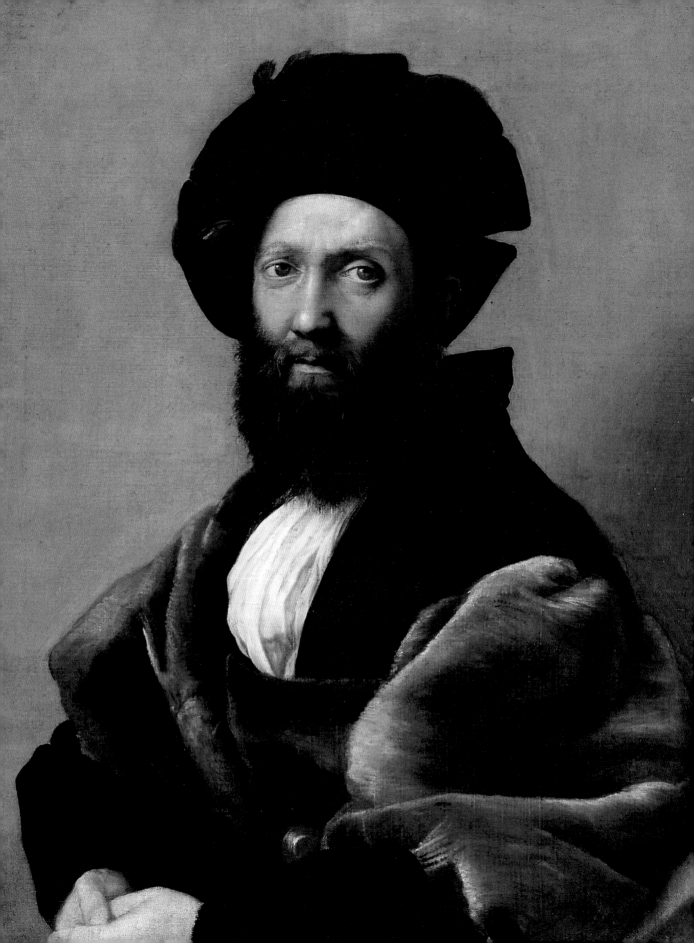

RAPHAEL, Painter in Rome

Silvia Ginzburg

I t is likely that Raphael arrived in Rome in the autumn of 1508, when he was twenty-five years old. According to Giorgio Vasari's account in the *Lives* (1550 and 1568), the main source for reconstructing the artist's career, it was the architect from Urbino Donato Bramante who suggested to Julius II to bring in Raphael for the decoration of his apartments in the Vatican, which had just been started by a team of painters, all of whom were quickly dismissed by the pope as soon as he saw Raphael's work.

The turn of the sixteenth century, saw the arrival in Rome of the leading figures of a more modern humanism that had developed out of the grand period of study in Lorenzo the Magnificent's Florence and the cities that had most embraced its legacy: Padua, Venice, the refined courts of Mantua and Urbino and the more cultured circles north of the Alps. Under Julius II, and even more so Leo X, Rome led the renewal of arts and letters still known today as the High Renaissance, which was celebrated by contemporaries and in the centuries to come as a new golden age. Drawing its centrality from an entirely new relationship with antiquity, studied and reinterpreted with the tools of a new form of philology, Rome was, in the name of an entirely modern culture, taking over the role that had belonged to Florence in the previous century, acquiring a primacy upon which it was still constructing its greatness in the Baroque period and beyond. Raphael quickly became one of the greatest emblems of this period, universally recognised as one of its apices.

Having received the commission to fresco the Stanza della Segnatura and the Stanza di Eliodoro (pp. 18–29) from the Della Rovere pope, who had already asked Michelangelo to build his tomb (a project of complex gestation that, after many modifications, was installed in San Pietro in Vincoli), and to paint the Sistine Ceiling, the artist from Urbino immediately obtained commissions of the highest prestige, and would increasingly continue to do so during the Leonine papacy up to his death in 1520. In addition to Julius II and Leo X, he also worked for other influential patrons: the powerful banker Agostino Chigi (pp. 62–71, 74–77), the cardinal Giulio de' Medici (pp. 44–45, 88–89), humanists and men of letters with important roles in the curia, such as Sigismondo de' Conti (pp. 38–39), the papal protonotary Johann Goritz (pp. 72–73) and those who came to Rome upon the election of Lorenzo de Medici's son to the papal throne in 1513. Among them, those who had met and appreciated the young painter at the Urbino court: Baldassarre Castiglione, of whom Raphael painted a celebrated portrait (**fig. 1**) and with whom he later wrote the *Letter to Leo X* (pp. 92–93), Pietro Bembo (pp. 46, 78–79), and the cardinal Bernardo Dovizi

fig. 1
Raphael,
Portrait of Baldassarre Castiglione,
1513 ca. Paris,
Musée du Louvre

da Bibbiena (pp. 46–49). These men of letters went on to become the greatest interlocutors and supporters of Raphael and his dizzying stylistic development, sharing the goal of coining a modern language founded on the dynamic interpretation of the legacy of antiquity.

The painter was aided in this not only by his extraordinary talent but also his early formation, first in the Marche and Umbria, with reference to the work of Perugino, Signorelli and Pinturicchio, and then, during his four years in Florence (1504–1508), in relation to that of Fra Bartolomeo, Leonardo and Michelangelo, the leading figures of what Vasari later described as the "modern manner" and a far greater influence on Raphael's future development. Already at a very young age, thanks to his training in Urbino under his father and the scholars of the Montefeltro court, rooted in the principles of modern humanist culture, Raphael had in fact acquired a mode of personal stylistic development founded on the combination and independent reinterpretation of different models, always achieving original and powerfully innovative results—a characteristic that distinguished him in the eyes of his contemporaries and that would be held up as a model by Vasari and, by extension, through him for the entire sixteenth century and beyond.

Considering its importance for the culture of his time, this method of development, and the intelligence with which Raphael engaged with Michelangelo's work, on multiple occasions and with fresh results each time (pp. 18–35, 40–43, 62–67, 72–73), thus opening the path to the most important interpretations of the latter that emerged from sixteenth-century artistic culture, we can now see that Raphael was the first Mannerist, although it was also Raphael who was taken as a model for the Carracci's naturalistic battles at the end of the sixteenth century, and later, from the seventeenth to the nineteenth centuries, he was considered the supreme representative of classicist and academic culture.

Raphael's Roman period offered him not only the opportunity to engage with new works by the artists he had already studied in Florence, but also that of combining these influences with his experiments with colour and light inspired by contact with the Venetian painting of Giorgione and the young Titian, through the work of Sebastiano del Piombo and others that still need to be identified.

His time in Rome was also critical as an opportunity to reckon with the varied, rich legacy of antiquity, studying the vestiges of ancient architecture, sculpture and painting in his roles of Architect of St Peter's (1514), and superintendent of excavation material (1515), in the antiquities collections of his patrons, during his study trips. These studies were carried out with his humanist friends, such as in the excursion to Tivoli in 1516 (pp. 46, 78–79, 92–93), as well as with his students, including his visits to the Domus Aurea and other sites that allowed close-up examination of ancient painting and decoration.

Starting in the middle of the 1510s, Raphael had his own school, composed of artists with diverse backgrounds and hence varied stylistic characters, to whom he assigned different roles within the workshop and who took on increasing responsibility for the work carried out, always led by the master. Raphael prepared the designs and contributed the finishing touches at the end (pp. 68–69), increasingly limiting his own contributions up to the project for the Vatican Loggias (pp. 51–55), for which he made the preparatory studies but left the rest to his assistants.

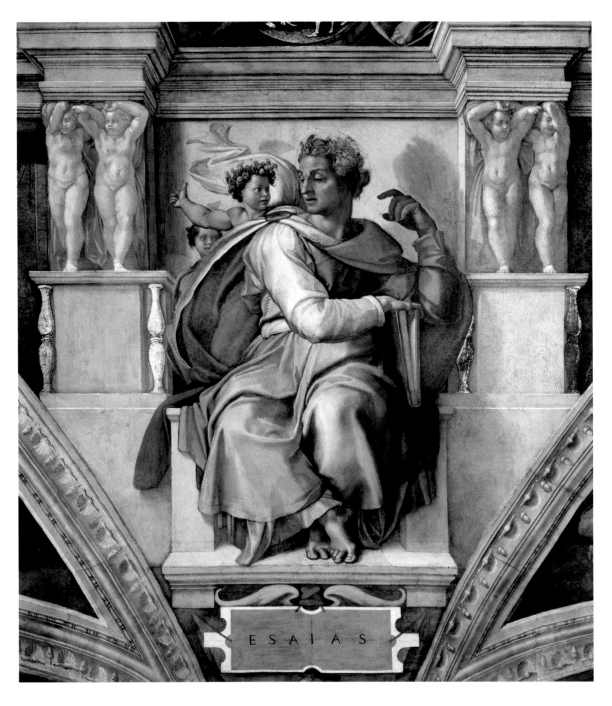

ESAIAS

The dizzying acceleration of Raphael's stylistic development in Rome can be understood primarily through the frescoes for the Vatican Stanzas and other works produced elsewhere during the same period. In the Segnatura (pp. 18–23), we find clear evidence of his discovery of Michelangelo's work on the Sistine Ceiling (**fig. 2**)—possibly seen in secret from the scaffolding with the complicity of Bramante— which comes to light in the *Parnassus*, datable to 1510, and, shortly after his study of the first half of the vault, unveiled in the summer of 1511,

fig. 2
Michelangelo, *Isaiah*,
1508–1510 ca.
Vatican City,
Vatican Museums,
Sistine Chapel

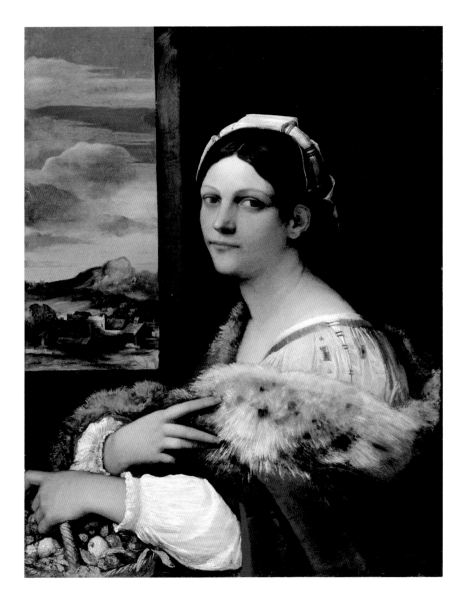

in the *Virtues* and in the Chigi Chapel in the church of Santa Maria della Pace (pp. 62–65).

Publicly unveiled in its entirety in October 1512, the model of the Sistine Ceiling can be found in some sections of the Stanza di Eliodoro (p. 26), intertwined with the discovery of Venetian painting, evident in the extraordinary effects of light and colour that dominate these frescoes (pp. 24–29). The latter aspect is traditionally explained by Raphael's proximity to Sebastiano del Piombo, who was brought to Rome by Agostino Chigi in the summer of 1511, and worked alongside Raphael in the Loggia of Galatea (pp. 66–67). Sebastiano's work reveals in turn that he had studied Raphael's way of conceiving portraits around 1512 (**fig. 3**).

The Raphael of 1512 was above all the unrestrained colourist of the second Stanza, the *Portrait of Julius II* in the National Gallery, London, and the *Madonna di Foligno* (pp. 38–39). In 1513, the bright palette, light effects and free handling of paint

in the *Meeting between Leo the Great and Attila* (pp. 27) and *Isaiah* (pp. 72–73) were employed to recreate the tridimensional effects of ancient sculpture, reread in terms of dynamism and stressing contrapposto, following the example of Michelangelo.

Evidence of Raphael's renewed engagement with the Sistine Ceiling is found in the completely changed style of the scene of the *Fire in the Borgo* from 1514 (pp. 30–33), where we find the results of his study of ancient and modern architecture in the new role of Architect of St Peter's (pp. 13–14, 90–91).

Whereas on the other hand, the *Liberation of St Peter* in the Stanza di Eliodoro (pp. 28–29) reveals fresh dialogue with Leonardo, who was in Rome from 1513 to 1516, hosted in the Belvedere close to where Raphael was working, and a profound influence on various works from Raphael's mature period, from portraits (fig. 1 and pp. 80–81) to the *Transfiguration* (pp. 44–45).

We can also follow the path of Raphael's interpretation of ancient sculpture and painting, as he studied works previously admired by Michelangelo, such as the *Belvedere Torso* (pp. 66–67), as well as the antiquities held in Roman collections, such as the statues belonging to Agostino Chigi, or the *Ciampolini Jupiter* (pp. 72–73), which had just been unearthed. It is plausible that the meeting with the architect and great antiquarian Giovanni Giocondo, who was in Rome from 1514 until his death the following year, led the artist to his philological interpretation of antiquity in the Bibbiena Apartment (pp. 46–49) and, most importantly, the discovery of a broader range of ancient examples.

On this front, the most important pieces to Raphael as a painter were the *Muses* discovered in Tivoli at the beginning of the century (**fig. 4**) and already studied by Leonardo, Michelangelo and Raphael himself, possibly in the ceiling of the Stanza della Segnatura, but then powerfully rediscovered and integrated into his later work, as evidenced in his contribution to the decoration of the Sala di Costantino (pp. 34–35), later completed by his pupils. It was Raphael who made these seated sculptures, marked by "mannered" contrapposto and pleated drapery, the model destined to replace, in the taste of what has been called the Mannerist generation, the *Laocoön* and the other ancient sculptures, celebrated at the beginning of the century.

fig. 4
Terpsichore,
130-150 CE.
Madrid,
Museo del Prado

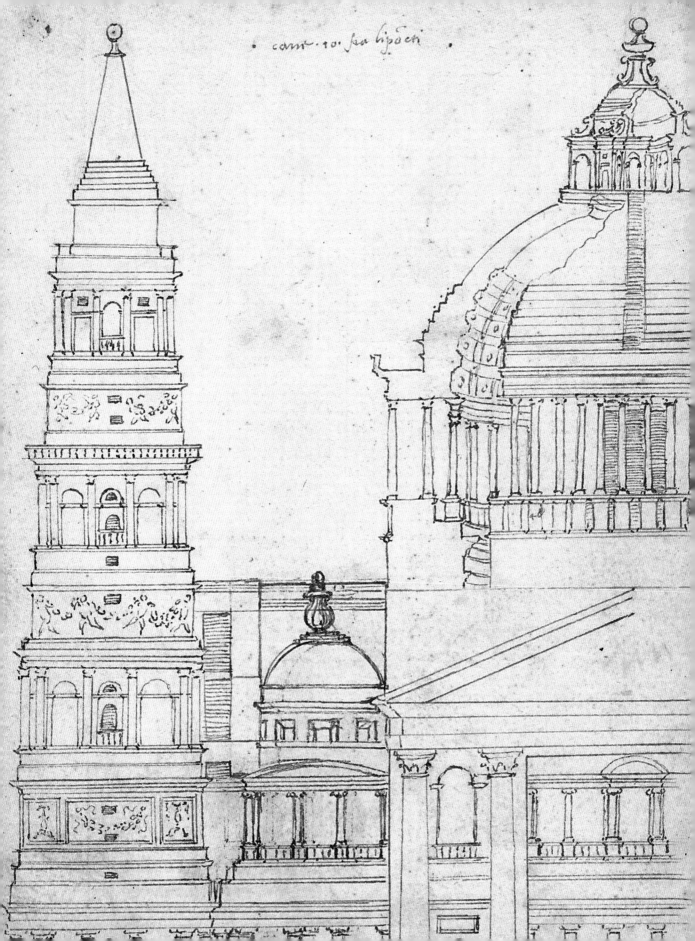

cam. 10. fa lipdei

RAPHAEL, Architect in Rome

Francesco Benelli

Raphael began his career as an architect in about 1513, when the wealthy Sienese banker Agostino Chigi commissioned him to design the stables on the grounds of his villa in via della Lungara (pp. 70–71). From that year forward, his architecture commissions overlapped with those for paintings, quickly becoming his primary occupation. His first contact with architecture was, however, during his youth, when, growing up in Urbino, the avant-garde architecture fostered by Federico da Montefeltro and designed by Luciano Laurana, Francesco di Giorgio Martini and Baccio Pontelli formed the natural visual backdrop of his everyday life. This early experience was limited solely to perception of the modern forms of this architecture, aided by his familiarity with perspectival representation through the works of Piero della Francesca and his own father, Giovanni Santi. His transition to the practice of architecture came through painting, at the very end of the fifteenth century, when it is thought that he might have followed Perugino to Florence, a city filled with the founding architecture of humanism, from the works of Filippo Brunelleschi and Leon Battisti Alberti to those of Giuliano da Sangallo. Compared to the architecture in Perugino's paintings, that in those of the young Raphael was more realistic and followed more modern models. We can appreciate this in the drawings that he made for Pinturicchio's frescoes in the Piccolomini Library in the Siena Cathedral (1502–1503) and in the *Marriage of the Virgin* at Brera (1504), which is a modernised response to works by Perugino (*Christ Giving the Keys to St Peter* in the Sistine Chapel and the *Marriage of the Virgin* at the Musée des Beaux-Arts in Caen).

In Rome, after he began the decoration of the Stanza della Segnatura (pp. 18–23), it became clear that Raphael was quickly mastering the principles of classical and contemporary architecture, both of which transmitted by Bramante, the primary figure behind his formation as an architect. The fictive architecture in the frescoes in the Stanze is filled with borrowed spatial and stylistic features, with the *School of Athens* (pp. 22–23), for example, drawing on Bramante's grandiose project for New St Peter's (1506), which was beginning to take concrete form in precisely those years, producing formal and structural effects never before seen and comparable only to the great ruins of antiquity. Raphael also learned from Bramante how to express the classical language of architecture through the architectural order, which is to say a structural and decorative system made up of columns, capitals and entablatures that Brunelleschi and Alberti began to rediscover in the 1420s. Bramante and Raphael used the architectural order both in superimposed levels

13

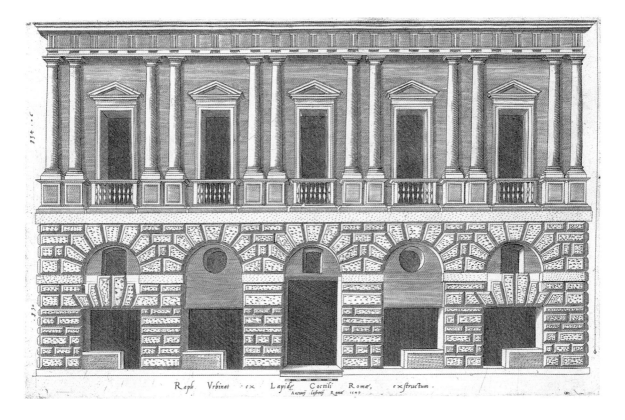

fig. 6
Antoine Lafréry,
elevation of the façade
of Palazzo Caprini in
*Speculum Romanae
Magnificentiae*, 1570s

and in gigantic dimensions, examples of which are identifiable in ancient ruins such
as the Colosseum, the Temple of Hadrian in Piazza di Pietra and the portico and
interior of the Pantheon (**fig. 8**). Their knowledge of theoretical and classificatory
rules came instead from Vitruvius's treatise *De Architectura*, a fundamental source
for the cultured, modern architects of the Renaissance. Printed for the first time
between 1484 and 1486, it was not, however, until the editions of the second de-
cade of the sixteenth century—illustrated and with a philologically accurate text
established by Fra Giocondo—that the work became more understandable, and
hence more often used. Like Bramante, who may have told the younger architect
about his inventions for the fictive choir of the church of Santa Maria presso San
Satiro in Milan, Raphael solved the refined perceptive problems of some of his ar-
chitectural works by thinking like a painter. Two examples are Palazzo Jacopo da
Brescia (pp. 84–85) and Palazzo Alberini (pp. 86–87), in which extremely subtle
constructive and compositional devices render the facades far grander than they
actually are. Lastly, Raphael also adopted the revolutionary economic use of build-
ing materials that Bramante had employed for the first time in the palace for the
cardinal Adriano Castellesi (begun 1501) and then in Palazzo Caprini (**fig. 6**; now
destroyed, construction begun 1501; purchased by Raphael himself in 1517), where
the costly marbles for the facade were replaced with plaster imitations, ensuring
the same *dignitas* but at a much lower cost. This innovation made it possible for the
upper middle classes to have *all'antica* triumphal facades that had been until then
exclusive to an elite of cardinals and princes. Raphael chose this technique for Villa
Madama, as well (pp. 88–89).

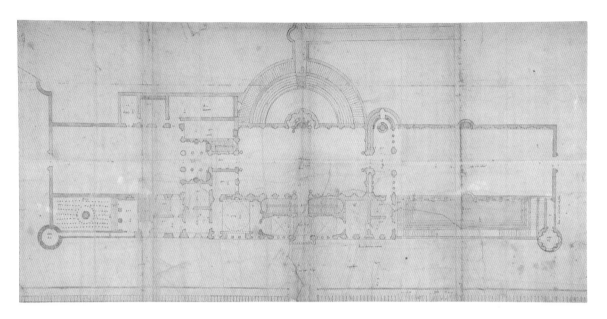

fig. 7
Giovanni Battista
da Sangallo, copy of
Raphael's plan for the
Villa Madama of 1518.
Florence, Gallerie
degli Uffizi, Gabinetto
Disegni e Stampe,
inv. 273 Ar

Besides Raphael, Bramante influenced at least an entire generation of architects working in Rome, including Baldassarre Peruzzi and Antonio da Sangallo the Younger, who, although beginning their careers in the stylistic wake of the master, went on to take different paths. Raphael, on the other hand, while differentiating himself from Bramante, never fully separated from the older architect, perhaps partly in recognition of the person who had recommended him to Julius II for the decoration of his apartments, the commission that clinched his fame. It also needs to be kept in mind that Raphael's career as an architect, however intense, only lasted seven years, a very short period with respect to the careers of his rivals, but within which he achieved results that were just as important and influential. Most of his projects are, for that matter, datable between 1513 and 1516: from the Chigi commission for the stables and the banquet loggia of the Villa in via della Lungara (pp. 70–71) and the one for the funerary chapel (pp. 74–77), Raphael moved on to the church of Sant'Eligio degli Orefici (pp. 82–83), Palazzo Jacopo da Brescia (pp. 84–85) and Palazzo Alberini (pp. 86–87). In 1514, having succeeded Bramante as Architect of St Peter's, he then took up the challenge of the plans for the immense basilica (pp. 90–91) and the Vatican Loggias (pp. 51–55), left unfinished by his predecessor.

Raphael primarily designed two categories of building: urban and suburban private residences on the one hand, and churches and funerary chapels on the other. In the former, we can perceive a clear progression in style and construction that begins with the Chigi stables, which were designed when Bramante was still alive and heavily influenced by Palazzo Caprini (**fig. 6**), featuring a main floor marked out by pairs of Doric pilasters. In the subsequent palaces for Jacopo da Brescia and Giulio Alberini, Raphael was instead faced with two irregular urban lots that presented complex compositional problems, which he solved with stunning brilliance. The respective facades, still Bramantesque, were built using subtle devices that improved the way they would be perceived. Finally, in the lost palace of Giovan Battista Branconio dell'Aquila, he adopted an extravagant decorative code made up of superimposed

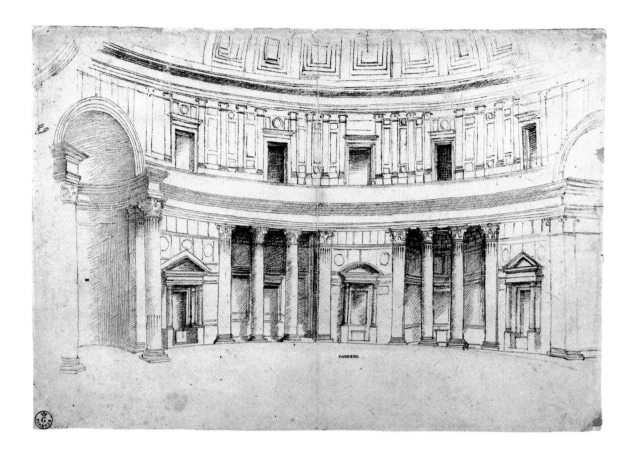

fig. 8
Raphael,
view of the interior
of the Pantheon,
1506–1508.
Florence, Gallerie
degli Uffizi, Gabinetto
Disegni e Stampe,
inv. 164 Ar

architectural orders that even embraced the ground floor—eliminating the rustica-
tion—and dense decoration including festoons, tondi, niches and gables, making
it a striking example of what has been described as the Leonine style. The latter
triumphed in the plan for the Villa Madama (**fig. 7** and pp. 88–89), conceived for
the cardinal Giulio de' Medici. The vast size and rich fresco and stucco decoration
of the villa would have produced a building that, had it been completed, would
have achieved a grandiosity such as had not been seen in Rome since the Imperial
Age. Raphael's religious architecture followed the same trajectory, from the spare
church of Sant'Eligio degli Orefici (pp. 82–83), which drew on the fifteenth-century
Florentine style, updated with Bramantesque elements, to the majestic plan for St
Peter's (pp. 90–91).

That same three-year span was also a period of generational transition for Roman
architectural theory and practice based on study of ancient ruins and Vitruvius: it
was marked by the deaths of Julius II, Bramante, Giuliano da Sangallo and Fra Gio-
condo, all individuals nourished by a typically fifteenth-century—and to a certain
degree still experimental—humanist culture. This knowledge was inherited and
then transformed by Leo X and his circle of humanists and artists, of which Raphael
became the supreme representative.

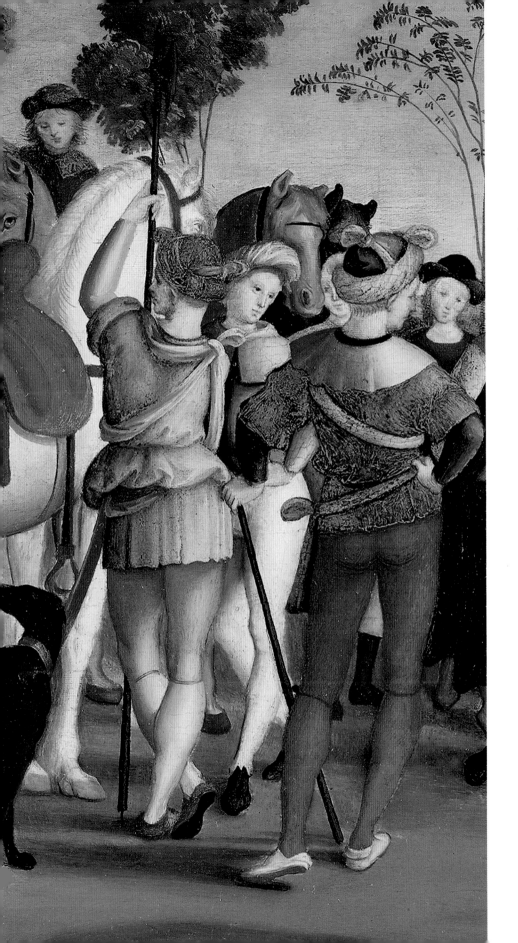

A Guidebook

1 The Stanza della Segnatura

1508–1511
Fresco
Vatican City, Vatican Museums

Raphael arrived in Rome in the autumn of 1508, called by pope Julius II, possibly at the suggestion of Donato Bramante, to decorate the Stanza della Segnatura.

The room takes its name from its use as the papal tribunal of the Segnatura during the time of Paul III, when it was described by Giorgio Vasari. The iconographic programme of the decoration has been understood for the most part as an illustration of the fields of medieval knowledge (*Theology*, *Jurisprudence*, *Philosophy* and *Poetry*, depicted in the tondi in the ceiling), and the room itself is held to have been the private library of Julius II. However, the subjects painted on the walls, with insistent reference to Julius II's patronage, portray the rebirth of those disciplines under the new pope who, after the savage papacy of Alexander VI Borgia, stood as a protector of the liberal arts and literature, and since a private library of the pope was on the floor above, it is possible that he was already carrying out duties as the head of the tribunal of the Segnatura in this space.

When Raphael arrived, the painter Giovanni Antonio Bazzi, known as Il Sodoma, was working on the divisions of the ceiling and the central oculus decorated with putti and eight vignettes with mythological scenes and episodes from ancient Roman history. Raphael joined the work on the ceiling, painting on a faux-mosaic background, within Sodoma's frames and grotesques, the four panels in the corners (*The Original Sin*, *The Judgement of Solomon*, *Astrology* and *Apollo and Marsyas*) and the four tondi with the female personifications of the disciplines, enthroned and accompanied by putti bearing citations drawn from ancient sources and linked to the episodes depicted in the nearby corner panels and the frescoes on the walls below. And so, *Theology* (DIVINARUM RERUM NOTITIA) is linked to the *Disputation of the Holy Sacrament* (the *Disputa*); *Philosophy* (CAUSARUM COGNITIO) to the *School of Athens*; *Poetry* (NUMINE AFFLATUR) to the *Parnassus* and the two monochromes designed by Raphael and painted by his pupils under Leo X of *Alexander the Great Commanding that the Work of Homer be Placed in the Tomb of Achilles* and *Augustus Preventing the Burning of Virgil's Aeneid*; *Jurisprudence* (IUS UNICUIQUE TRIBUIT) to the *Cardinal Virtues* and the two scenes below, *Justinian Receiving the Pandects from Trebonianus* and *Gregory IX Approving the Decretals*.

The two facing frescoes of the *Disputa* and the *School of Athens* can be read as the single space of a basilica under construction. The *Disputa*, a celebration of Trinitarian dogma and transubstantiation, is clearly divided into two parts. In the upper part, against a fan of golden rays with angels to the sides, God the Father, Christ,

Ceiling of the Stanza della Segnatura, detail of
The Judgement of Solomon

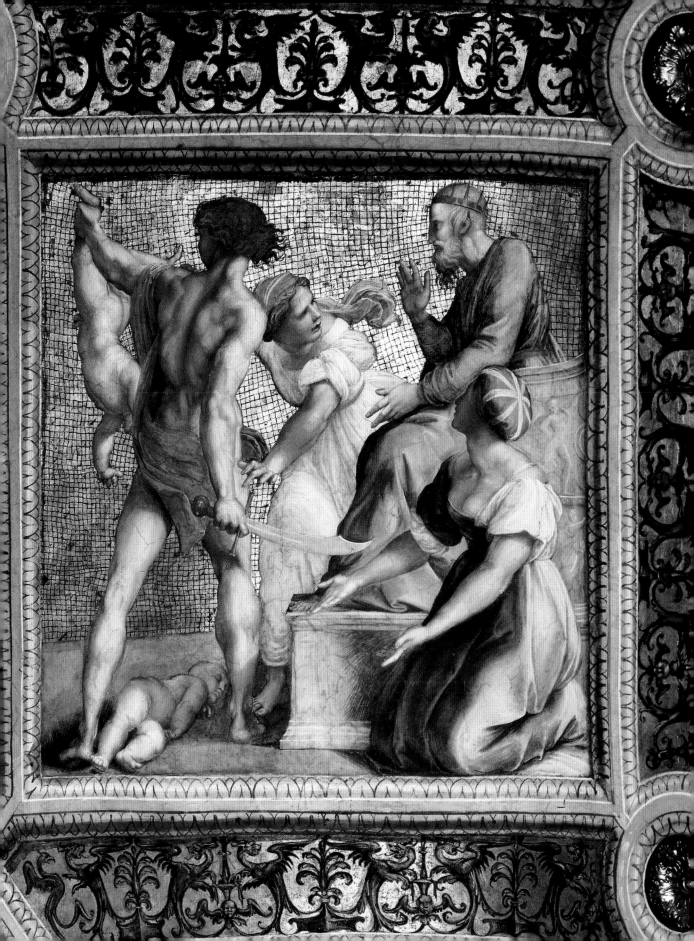

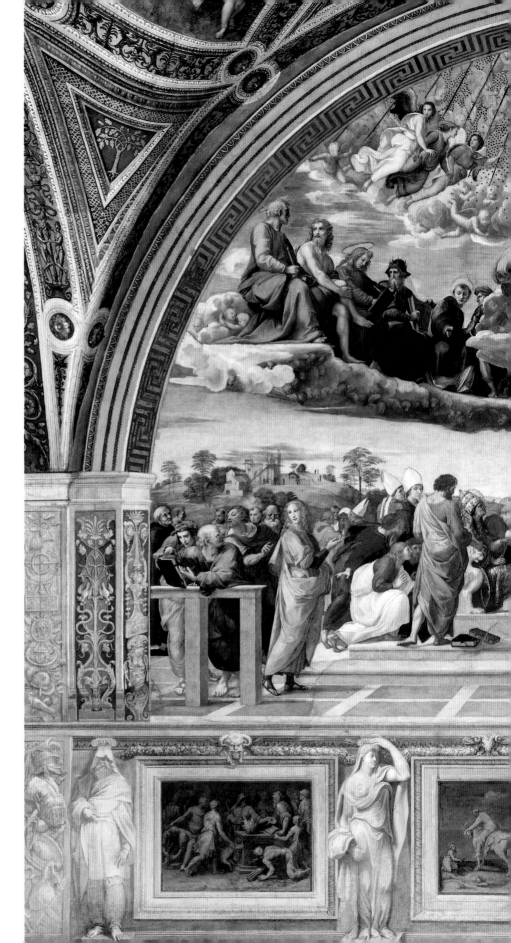

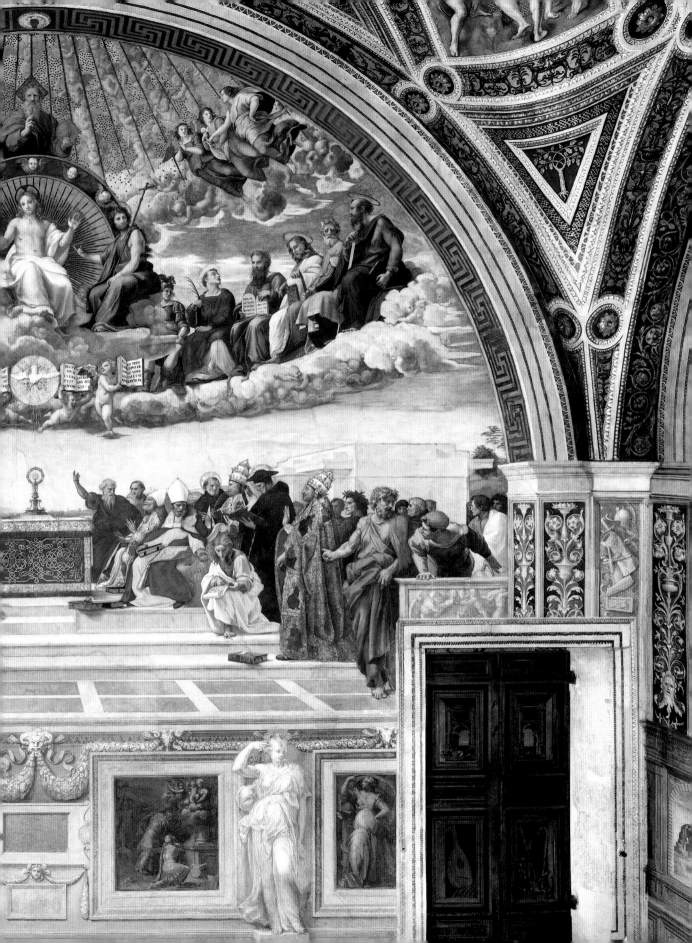

the Virgin, various saints and the Fathers of the Church are arranged on a semicircle of clouds populated with putti. Below them, to the sides of the altar where the Host is displayed on axis with the Trinity, are popes, prophets, founders of the mendicant orders and other figures. In this image, Raphael expressed everything that he learned during his Florentine sojourn (1504–1508): the semicircle of clouds is drawn from Fra Bartolomeo's *Last Judgement* (Florence, Museo Nazionale di San Marco) while the dialogue between the figures, enlivened with intensely naturalistic expressions and gestures, derives from his profound understanding of the work of Leonardo.

In the *School of Athens*, Aristotle and Plato advance towards the viewer inside a vast Bramantesque building, with a coffered vault reminiscent of the Basilica of Maxentius, surrounded by other learned men, the features of which are borrowed from the artist's contemporaries connected to Julius II's patronage. Among them, in the middle, Heraclitus, with the face of Michelangelo, was added only after the end of the artist's work on the room, as an homage to the painter who was frescoing the Sistine Chapel during the same period (1508–1512).

The third fresco to be painted was the *Parnassus*, which depicts Apollo and the Muses surrounded by ancient and modern poets. Here, the freer brushwork and monumental figures in the foreground in poses that extend beyond the limits of the wall were Raphael's first response to the frescoes in the Sistine Chapel, which he must have been able to see from the scaffolding before half of the ceiling was unveiled on 15 August 1511.

A fuller monumentality and deeper reflection on Michelangelo pervades the three generously draped *Virtues* on the opposite wall, the last to be painted and completed by the summer of 1511, the date inscribed on the intrados of the window. The fresco with Trebonianus on the left was painted by a different artist, the identity of whom remains uncertain, whereas the one on the right, with the splendid series of powerful figures, including Gregory IX with the features of Julius II, is all Raphael. The base was instead painted by Perino del Vaga, in about 1541.

FRANCESCA MARI

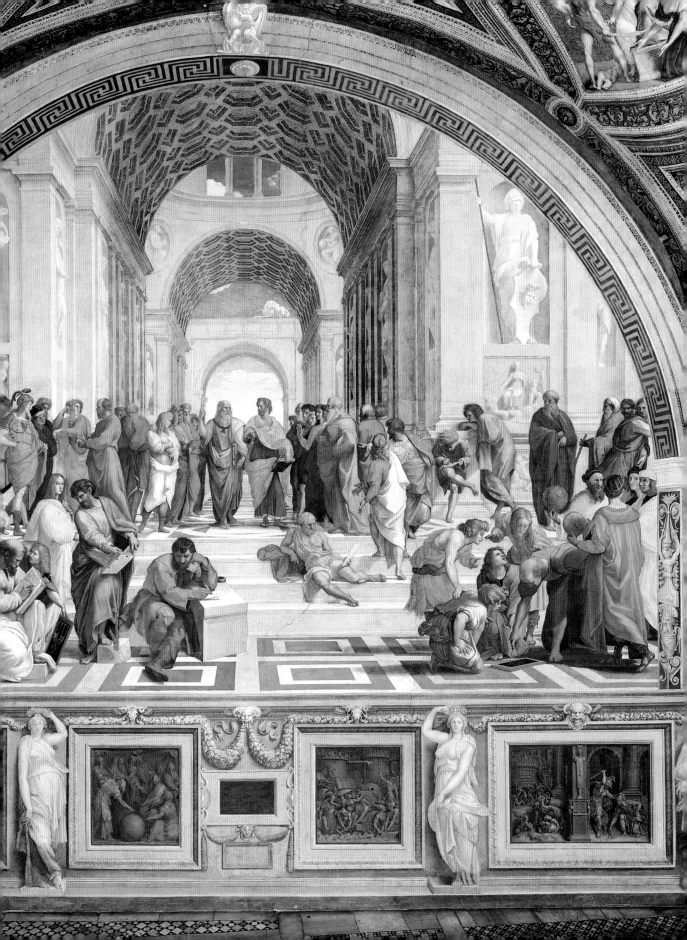

2

The Stanza di Eliodoro

1511–1514
Fresco
Vatican City, Vatican Museums

This was the second room in the apartments of Julius II to be frescoed by Raphael. In the summer of 1511, while he was completing the decoration of the adjacent Stanza della Segnatura, the artist was already developing his first ideas for the episodes to be painted in the Stanza di Eliodoro, which he worked on until 1514, when he received a payment for the completion of the work, by that point under the Medici pope Leo X.

This room was reserved for the papal audiences and the episodes frescoed on the walls had a political and diplomatic meaning, representing the ideal of the militant, triumphant Church of the time through the evocation of episodes from the past, rendered current through the insertion of portraits of, first, Julius II and, then, Leo X.

The east wall of the room is decorated with the *Expulsion of Heliodorus from the Temple*, which, according to most scholars, was probably the first episode to be frescoed, in the first half of 1512. The episode was drawn from 2 Maccabees and depicts, on the right, the moment in which two angels and a heavenly knight appear to expel Heliodorus, who had tried to steal the money from the temple earmarked for widows and orphans. On the left, we see Julius II carried in on a litter, as if he were witnessing the ancient historical episode. The pope is depicted with the beard that he presented himself in Rome in the summer of 1511, returning from his military campaigns in northern Italy. The powerful group with the vanquished Heliodorus, on the right, and that of the women frightened by the appearance of the heavenly messengers, on the left, were the fruit of Raphael's progressive development of the example of Michelangelo's frescoes on the Sistine Ceiling, the first half of which had been unveiled in August 1511.

The puissance of the bodies on the right part of the scene, with the fallen Heliodorus, might indicate that Raphael had seen the second half of the Sistine Ceiling and, in this case, its execution would come after that of the *Mass of Bolsena.*

In the latter scene, on the south wall, Raphael depicts the miracle of the bleeding Host in the Latium town in 1263, an episode again anachronistically witnessed by Julius II, who is portrayed in prayer on the right. The problem of the asymmetry of the wall, which is interrupted by a window, provided Raphael with an opportunity to devise a brilliant compositional solution, using the real window as a support for the painted scene, which is so heavily foreshortened that the viewer gets the impression of being under the altar. In the *Mass of Bolsena* we find an increasingly bright palette and a new focus on light effects, rendered with extremely free brushstrokes. The fields of colour that describe the clothing and the extraordinary portraits of the

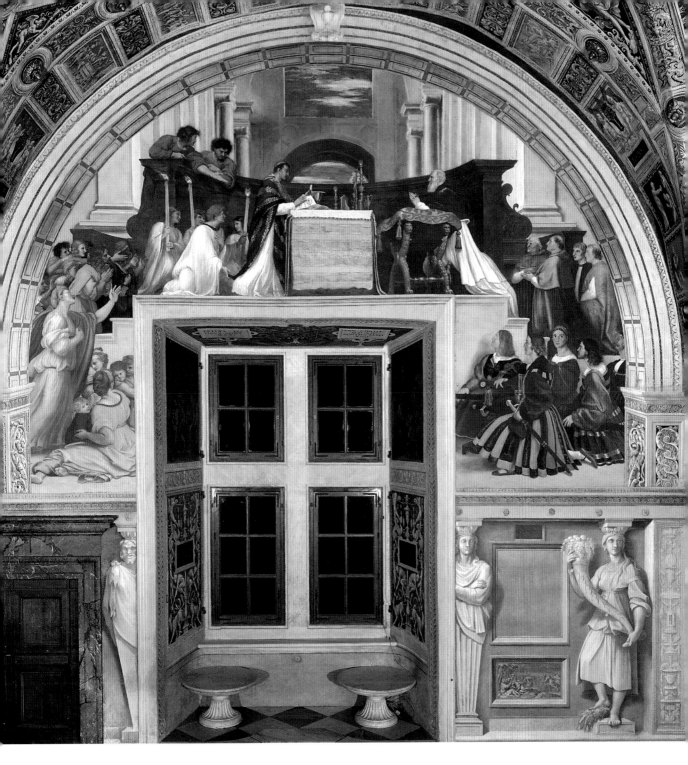

Mass of Bolsena

Swiss Guard at the lower right derive from Raphael's response to the search for co-lour and light in the Venetian painting of the time, in particular that of Sebastiano del Piombo and possibly Titian.

In the *Meeting between Leo the Great and Attila*, the crowding of the hoard of Huns led by their king on a black warhorse contrasts with the solemn group with

Mass of Bolsena

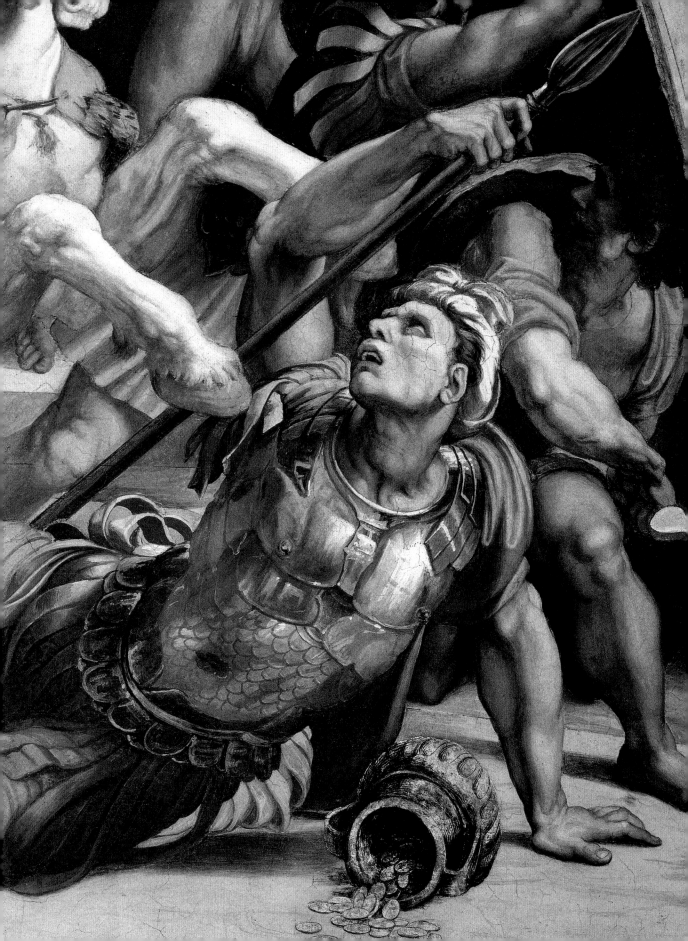

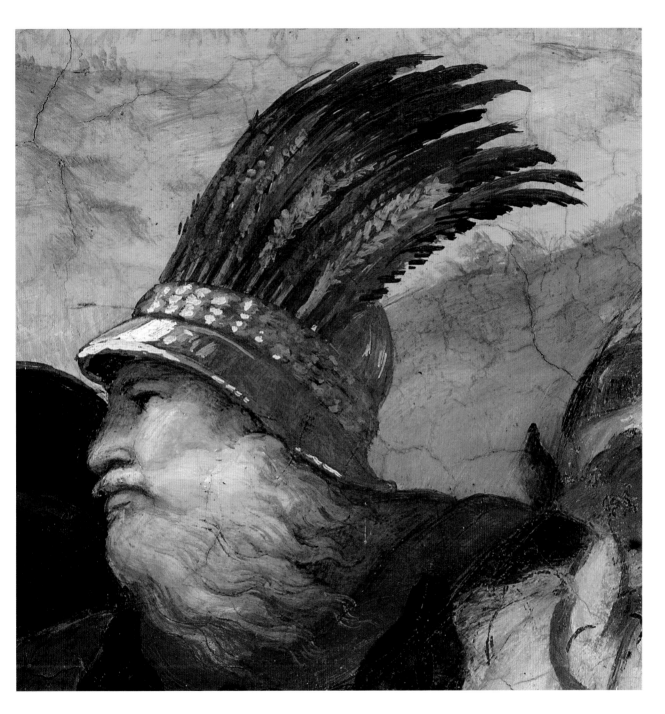

the portrait of the newly elected Leo X who, a modern figure inserted into the ancient historical episode, triumphantly enters Rome, not Mantua, where the episode took place, on his white mare. The astonishing chromatic flashes of the landscape that blazes in the background and in the way in which are painted some details of the scene, like the native American headdress worn by a member of Attila's following, a reference to the recent geographical discoveries, are here accompanied by new reflection on Michelangelo's frescoes on the Sistine Ceiling, completed in

27

October 1512. This further reaction to Michelangelo is connected to a greater attention to ancient sculpture, evident in the formulation of the figures in the foreground and in the citation from Trajan's Column of the Sarmatian soldier sheathed in crocodile skin on the far right.

A physical limitation is also exploited to the advantage of a brilliant pictorial solution in the case of the *Liberation of St Peter*, frescoed on the north wall. In this work, Raphael planned for and exploited the natural light that comes in through the window, which shines directly in the viewer's eyes, using it to lend more mystery to the otherworldly apparition of the luminous divine angel who frees St Peter, and increase the intensity of the other light sources, the moon and the torches. In the lower part of the fresco, on the right, the milky effect of the nighttime humidity, standing out against which are the dark forms of the soldiers guarding the prison, rendered with a peculiar technical solution, was possibly suggested by Leonardo, at that time in Rome.

Observation of Michelangelo and study of the antique drove the new phase of Raphael's work under Leo X in 1514, evident in the ceiling and the lower parts of the wall. On the vault and in the corbels to the sides of the windows, the artist worked on frescoes that had been begun during the first phase of the decoration of the Stanze, prior to his arrival. He decorated the ceiling with four fictive trapezoidal tapestries, illusionistically hung like ancient velaria and populated with powerful, colourful figures that enliven the episodes with God the Father and the angels who appear to the patriarchs of the Old Testament. On the lower part of the walls, interpreting Vitruvius's description of ancient caryatids, he devised astonishing, giant fictive monochrome sculptures bearing the attributes of Leo X's good government..

CRISTINA CONTI

3 The Stanza dell'Incendio di Borgo

1514–1517

Fresco

Vatican City, Vatican Museums

With the Stanza dell'Incendio di Borgo (Fire in the Borgo), painted between 1514 and 1517, Raphael entered a new stylistic phase, which was nascent in the Stanza di Eliodoro and coincided with the advent of the Medici pope Leo X. Consonant with the new pope's humanistic culture and role as protector of the liberal arts and letters (he was the son of Lorenzo the Magnificent) and stimulated by a new stage of the dialogue with Michelangelo's Sistine Ceiling and by his appointment as Architect of St Peter's in 1514 and Prefect of Antiquities in 1515, Raphael's style under Leo X was more stately and complex, characterised by strong contrasts of light and shadow, more emphatic, clearly defined forms and off-centre compositions. He also more frequently entrusted frescoes to his pupils, who worked based on his designs and under his supervision.

In this room, used as the pope's official dining room, the ancient historical episodes narrated on the walls, all involving popes named Leo and with reference to moments evoked by the Lateran Council, concluded by Leo X in 1517—the *Fire in the Borgo* and, counter-clockwise, the *Battle at Ostia*, *The Oath of Leo III* and *The Coronation of Charlemagne*—were at the same time devised to celebrate contemporary events, respectively: Leo X's effort to quell the fires of war in Italy, promotion of a new crusade against the infidels, affirmation of the pope's autonomy and the Medici pope's support for the imperial aspirations of Francis I, king of France.

When Raphael began work on the *Fire in the Borgo* in 1514, he decided to preserve the frescoes by Pietro Perugino and his workshop, completed by the autumn of 1508: the four segments of the ceiling and the arch, and the fictive pillars that still frame the scene today. The key moment of the episode is depicted in the background: with the sign of the cross, Leo IV stops the blaze that broke out in 847 in the neighbourhood near St Peter's. The vigorous figures on the forestage express

their fear with broad gestures. The architecture is dominant here, describing with theatrical effect and philological accuracy the styles of antiquity (the colonnades), the Middle Ages (the facade of Old St Peter's in the background) and the contemporary period (the building where the pope stands looking out, with a rusticated base and Serlian window).

The second fresco was the *Battle at Ostia*, in which the fleets supporting Leo IV defeated the Saracens. Raphael worked out the design for the fresco in meticulous drawings (one of which he sent to Albrecht Dürer in 1515), which were then translated into paint by his students, in particular Giulio Romano and Giovan Francesco Penni, who both played a dominant role in the decoration of this room.

Raphael also made preparatory drawings for *The Coronation of Charlemagne*, including portraits of his contemporaries and using a boldly off-centre perspective, which guides the viewer's gaze along the diagonal marked by the arm of the young man in the foreground towards the main scene, relegated to the background, in which Leo III has the face of Leo X and Charlemagne that of Francis I. The fresco was painted by Giulio Romano, fully recognisable in his autonomous artistic language, although the stunning group of prelates sitting on the ground, dressed in red, might be by the hand of Raphael. The master's contribution seems to fade in the *Oath of Leo III*, a work alluding to the supremacy of spiritual over temporal power, and painted by Giulio Romano and his assistants.

Raphael also designed the lower part of the walls, where fictive marble telamones alternate with the figures of six sovereigns, painted in monochrome yellow to simulate metal sculpture and identified by inscriptions above. Painted for the most part by Giulio Romano, this decorative formula of seated figures enlivened by different movements, reinterpreting the model of Michelangelo's *Prophets* and *Sibyls*, went on to enjoy great success.

CAMILLA COLZANI

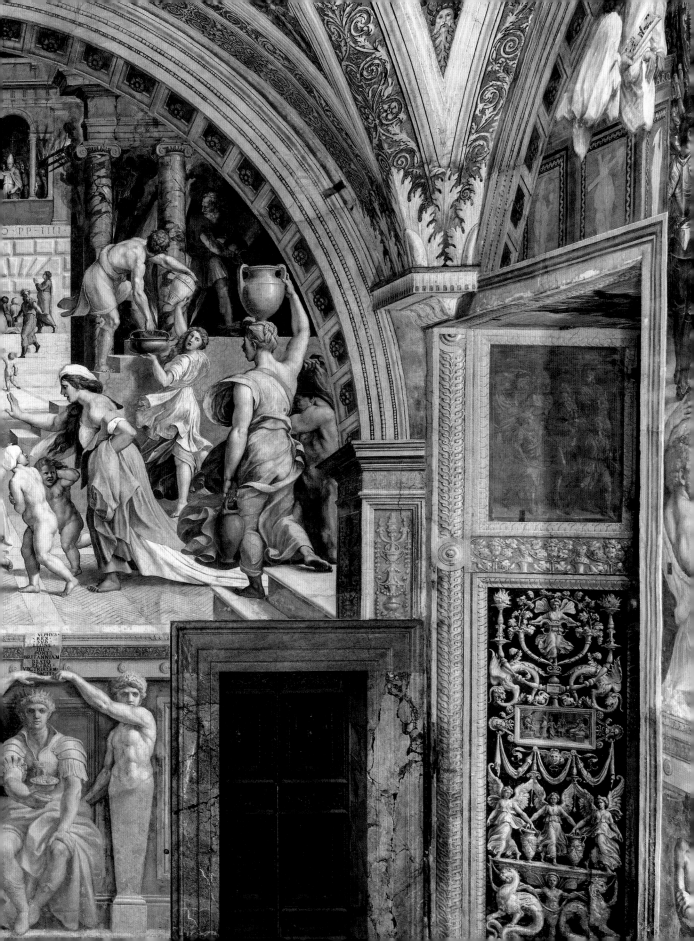

4 The Sala di Costantino

1519–1524
Oil on wall, fresco
Vatican City, Vatican Museums

Raphael's final pictorial project for the Vatican, interrupted by his death in April 1520, the Sala di Costantino preserves sections that he painted when the work began, specifically the figure of *Justice*, pictured here, and that of *Comitas* (a Latin term for friendliness, kindness), both painted in oil on the wall and invaluable evidence of his original intention to carry out all of the decoration using this unusual technique.

Adjacent to the pope's private apartments and quite large in size, this room was well suited to hosting banquets, receiving ambassadors, appointing cardinals and hosting high-ranking individuals who would have undoubtedly been impressed by the magnificence of the painting and the eloquent iconographic programme aimed to celebrate the superiority of papal power over imperial power.

Leo X entrusted Raphael with the conception of the fresco cycle of episodes from the life of the Emperor Constantine in the spring of 1519. Work was to begin in October, following Raphael's plan. Before his premature death, he produced the drawings for two of the scenes (the *Battle of the Milvian Bridge* on the south wall and the *Vision of Constantine* on the east wall) and a few figures, which were then translated into fresco by the pupils who inherited the worksite, Giulio Romano and Giovan Francesco Penni, and their assistants.

Interrupted by the death of Leo X (December 1521), work was resumed in November 1523 under the new Medici pope Clement VII and completed by the autumn of 1524 (*Donation of Constantine* on the north wall, *Baptism of Constantine* on the west wall).

The brilliant solution of painting fictive architecture on the wall met the need of making an irregular space visually uniform. The episodes from the life of Constantine are presented as if depicted in richly woven tapestries. Above a base lavishly decorated with monochrome scenes and fictive stone caryatids, eight niches at the ends of the walls host the thrones of eight papal saints—from Peter to Gregory the Great—flanked by female personifications of the Virtues, seated figures designed by Raphael in his final style, rereading the Sistine Ceiling in light of renewed contact with Leonardo, who was in Rome between 1513 and 1516, and his own study of ancient sculpture.

The wooden ceiling commissioned in 1518 by Leo X was later replaced with a vault frescoed by Tommaso Laureti between June 1582 and October 1585, first under Gregory XIII and then Sixtus V.

SERENA QUAGLIAROLI

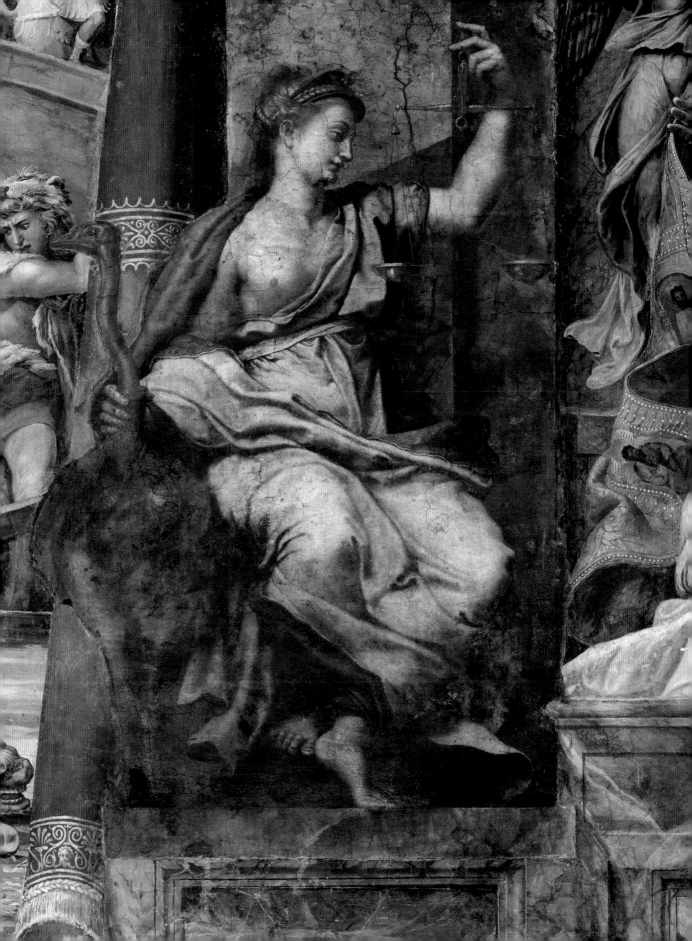

Coronation of the Virgin

Annunciation, Adoration of the Magi, Presentation in the Temple

ca. 1503
Tempera grassa on wood transferred to canvas, 272 × 165 cm
Tempera grassa on wood, ca. 39 × 190 cm (predella)
Vatican City, Vatican Museums, Pinacoteca Vaticana

Raphael was commissioned to paint the *Coronation of the Virgin*, also known as the Oddi altarpiece, by Alessandra (Leandra) Baglioni, wife of Simone di Guido degli Oddi, for the family chapel dedicated to the Virgin in the church of San Francesco al Prato in Perugia, for which the artist painted the *Deposition*, now in the Galleria Borghese, a few years later (pp. 60–61).

The painting was seized by French troops in 1797, acquired by the Musée Napoléon, Paris, and transferred to canvas. Returned to Italy in 1816, it is now preserved in the Pinacoteca Vaticana with its three predella panels depicting the *Annunciation*, the *Adoration of the Magi* and the *Presentation in the Temple*.

Study of the numerous preparatory drawings reveals that Raphael originally intended to paint an *Assumption of the Virgin*, a subject that would better explain the presence of the empty sarcophagus surrounded by the Apostles in the lower part of the painting.

Noted by Vasari as one of the early works by Raphael closest in style to Perugino, the altarpiece has always been put in relation to the temporary return from exile of the male members of the Oddi family to Perugia, which took place in 1503, and this date remains the most probable for the painting due to its style, even if the role of women from this family who remained in the city is taken into consideration. Thanks to recent conservation work the blue in the cloak of the Virgin has re-emerged, as have the beautiful chiaroscuro passages in the colours.

The liveliness of the description of the Apostle's various poses and the movement of the angels' drapery reveal stylistic elements derived from Pinturicchio, with whom Raphael worked creating drawings for both the Piccolomini Library in the cathedral of Siena, commissioned in June 1502, and the *Coronation of the Virgin* of Umbertide, now in the Pinacoteca Vaticana, completed in June 1503. This date is further confirmed by the heavy influence of models by Perugino, evident especially in the predella and typical of Raphael's work between 1503 and 1504.

FRANCESCA MARI

Hope, Charity, and Faith

(predella of the Transport of Christ to the Sepulchre) see pp. 60–61

1507
Tempera grassa on wood, each panel 18 × 44 cm
Vatican City, Vatican Museums, Pinacoteca Vaticana

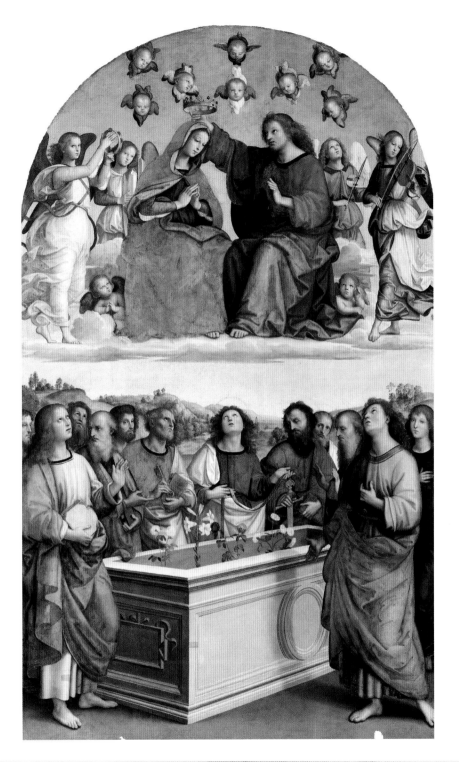

7 The Madonna di Foligno

1512
Tempera grassa on wood transferred to canvas, 308 × 198 cm
Vatican City, Vatican Museums, Pinacoteca Vaticana

The *Madonna di Foligno* was painted for Sigismondo de' Conti, humanist and secretary to Julius II, who commissioned it before his death in February 1512 for his tomb near the presbytery of the Roman church of Santa Maria in Aracoeli. The altarpiece, which has always been celebrated as one of Raphael's greatest achievements as a colourist, is dated to 1512 based on its proximity to the *Mass of Bolsena* (pp. 24–25). The portrait of the patron, kneeling in devotion in the bottom right and presented to the Virgin by St Jerome, must, however, be considered posthumous and possibly inspired by a death mask. In 1565, in accordance with the will of Sigismondo's heirs, the painting was moved to the monastery of Sant'Anna in Foligno, the Umbrian town where the humanist was born. Seized by Napoleon's troops in 1797, it was brought to Paris, where the painting on wood was transferred to canvas. As part of the restitutions agreed at the Congress of Vienna in 1816, the painting was moved to the Vatican.

Recent restoration work has brought back the splendid hues of the background and drapery as well as the soft, delicate light and shadow of the figures' complexions, immersed in the atmospheric description of the clouds and the stunning landscape, marked by buildings defined by filaments of light, a rainbow and a fiery object falling on the right, leaving miraculously untouched Sigismondo de' Conti's house in Foligno.

Sts John the Baptist and Francis on the left, the small angel holding the plaque in his hands, St Jerome, and the donor on the right all direct their attention to the divine group above, in which we find the Florentine influence of Leonardo's *Adoration of the Magi* in the Virgin, Michelangelo's *Doni Tondo* in the Christ Child and works by Fra Bartolomeo in the rendering of the clouds in the shape of putti.

The beautiful stretch of landscape, which was in the past attributed to Dosso Dossi due to the strong link to Giorgione's painting, is now recognised as being solely the work of Raphael, working at the height of his exploration of colour and light.

CRISTINA CONTI

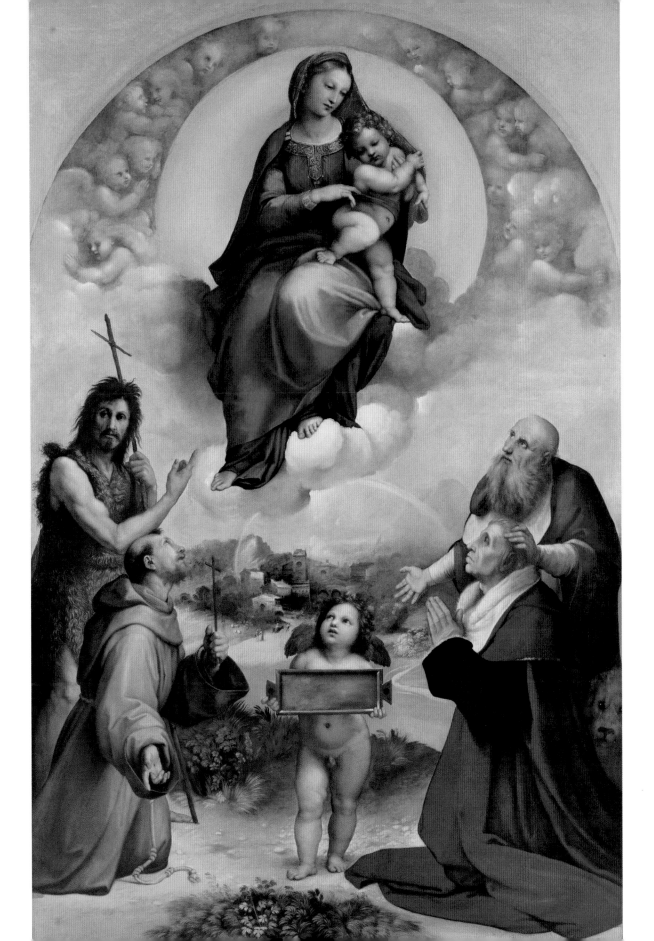

The Tapestries of the Acts of the Apostles

ca. 1514–1516 (cartoons), ca. 1517–1519 (tapestries)
Vatican City, Vatican Museums, Pinacoteca Vaticana

The ten tapestries depicting the *Acts of the Apostles* were produced in Brussels in the workshop of the tapestry maker Peter van Aelst, for the most part between 1517 and 1519, to be hung on the lower walls of the Sistine Chapel. They are based on tempera cartoons by Raphael and his assistants, seven of which are now in London at the Victoria and Albert Museum. This was the most lavish project entrusted to Raphael by Leo X, for which the painter received, going by the memory of the Venetian humanist Marcantonio Michiel, about 1,000 ducats, but the only payments that are known are one in June 1515 for 300 ducats and the final payment in December 1516 for 134.

According to the sources, on 26 December 1519, the first seven tapestries to arrive in Rome were hung in the Sistine Chapel, the space for which they were commissioned and where they were displayed for special celebrations, beneath the stories of Moses and Christ commissioned by Sixtus IV and in visual communication with the frescoes by Michelangelo on the vault.

The stories of Sts Peter and Paul (*Christ's Charge to Peter*, *The Miraculous Draft of Fishes*, *The Death of Ananias*, *St Paul Preaching at Athens*, *The Sacrifice at Lystra*, *The Blinding of Elymas*, *The Conversion of Saul*, *The Stoning of St Stephen*, *The Healing of the Lame Man* and the small *Liberation of St Peter*) are accompanied by the narration of the deeds of Leo X when still a cardinal with the name Giovanni de' Medici, represented in monochrome in the partially-preserved borders.

The translation of Raphael's designs into tapestry, conceived in mirror-image in the cartoons, is at its height in its interpretation of the chromatic and chiaroscuro passages and the softness of the complexions, achieved through the use of precious materials like silk, gold and silver yarn, immediately provoking profound admiration. The project marked a critical junction in the artist's career, not only because it provides an early example of the functioning of his workshop, busy painting cartoons on the master's designs and under his strict supervision, but also because it is evidence of an important moment in the development of Raphael's artistic language, with the artist returning to reflection on Michelangelo's Sistine Ceiling and revealing his intense and varied interest in architecture and ancient sculpture, which was now beginning to dominate his artistic exploration. Particularly noteworthy are the naturalistic passages introduced by Giovanni da Udine, such as the great variety of fishes and the beautiful cranes at the forefront of the *The Miraculous Draft of Fishes*.

Comparison of *Christ's Charge to Peter* with *The Healing of the Lame Man*, which many believe were the first and last works in the series, reveals Raphael's clear

The Miraculous Draft of Fishes, detail

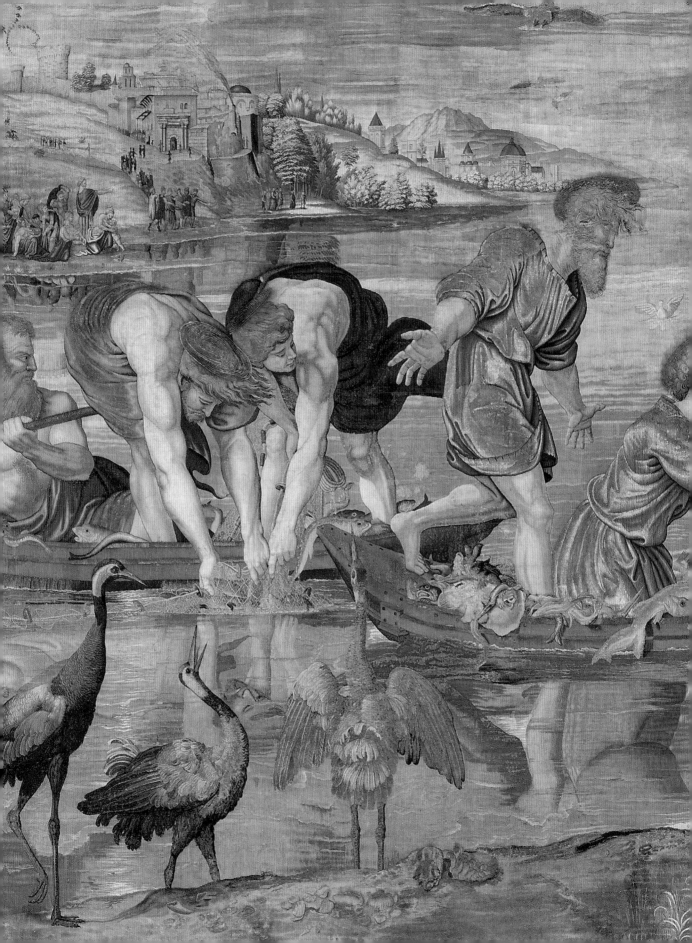

stylistic development, which proceeded in the rendering of the figures towards an increasingly fervent expressive intensity and a more mannered approach to forms and gestures, which became progressively more agitated, eloquent and theatrical.

The architecture depicted in the tapestries is contemporary to the projects Raphael executed for real buildings: for instance, the solution used by Bramante for the pillars of St Peter's, re-elaborated by Raphael in St Eligio (pp. 82–83) can be found in *The Blinding of Elymas*. In six of the ten tapestries it plays a major role, both figurative and narrative. The architectural backgrounds portray triumphal architectures composed of ancient elements — most famously the Solomonic columns in the *The Healing of the Lame Man*—combined in a modern manner which goes beyond Bramante's inventions. With a very innovative effect, the spectator is elicited to associate these structures with both the great Roman ruins and the most up-to-date architectures of those years.

CRISTINA CONTI

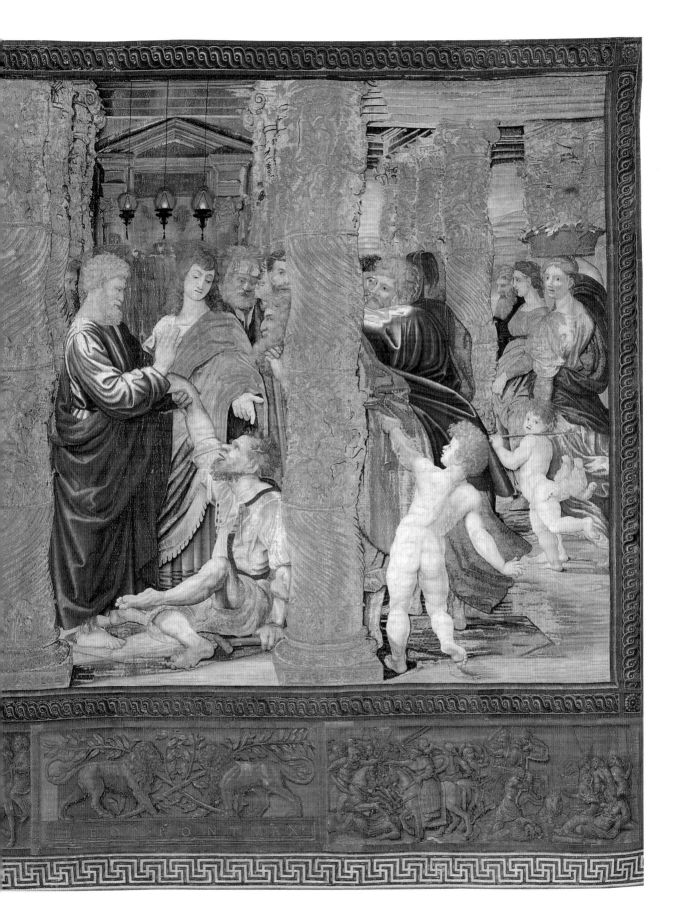

The Transfiguration

1516–1520
Tempera grassa on wood, 410 × 279 cm
Vatican City, Vatican Museums, Pinacoteca Vaticana

Begun in 1516 and completed just before the artist's death in 1520, the *Transfiguration* encapsulates the entirety of Raphael's development under Leo X.

The altarpiece combines two contiguous but separate Gospel episodes. In the upper part of the painting is the Transfiguration of Christ with the disciples Peter, John and James, to whom Christ manifests himself between the prophets Moses and Elijah. Below is, the "therapeutic failure" of the Apostles, who, in the absence of Christ, are unable to heal the obsessed boy who has been brought to them by his father (and who is later healed by Christ, when he comes down from Mount Tabor).

The painting was commissioned by the cardinal Giulio de' Medici, cousin of Leo X and archbishop of Narbonne since 1515, who first turned to Raphael for the cathedral's altarpiece, a *Transfiguration*, and immediately after to Sebastiano del Piombo, who was provided with drawings by Michelangelo, for a *Resurrection of Lazarus* (London, National Gallery), a dual request that generated, as described by a contemporary, a kind of competition, a "paragone", that inflamed Raphael. The original destination for the painting explains the presence of the two kneeling deacons at upper left, Sts Justus and Pastor, patron saints of Narbonne, the feast of whom falls, like that of the Transfiguration, on 6 August.

As revealed by the preparatory drawings, Raphael gradually developed the idea for the dual subject, the theatrical representation of Christ and the large theatre of emotions in the lower register. In this competition, however indirect, with Michelangelo, Raphael experimented with what he had drawn from his renewed contact with the work of Leonardo in Rome (1513–1516), including the expressive intensity of the figures' movement and faces, the dialogue of gestures that connects them to one another, the lucid transparency of the colours, experimentation with lampblack for the shadows and the use of heavy chiaroscuro to create relief—characteristics that shaped the art of Giulio Romano, who was indeed attributed with the lower part of the painting in the past.

Displayed above Raphael's coffin, the *Transfiguration*, unlike the altarpiece by Sebastiano del Piombo, was not sent to Narbonne in 1523, but was placed instead on the high altar of San Pietro in Montorio. Carried off by Napoleon in 1797, it was brought back to Rome in 1816 by Antonio Canova.

BARBARA AGOSTI

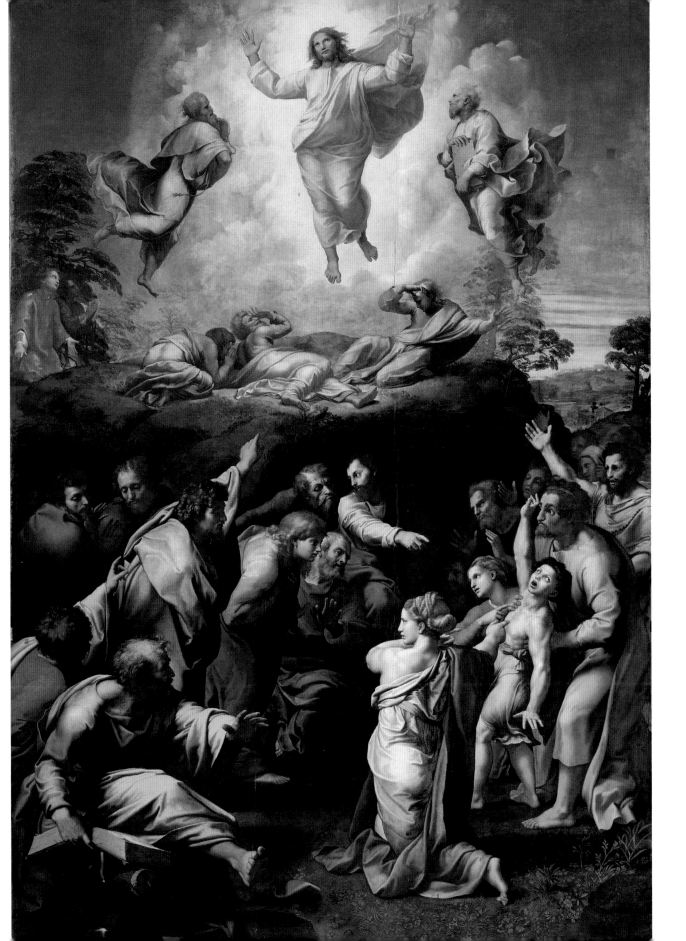

10 The Apartment of Cardinal Bibbiena

1515–1516
Fresco
Vatican City, Vatican Palaces

P ossibly since 1515, Raphael was under commission from Leo X to re-build and decorate an apartment that had burned in December 1514, located on the third floor of the Papal Palace and intended for the Cardinal Bernardo Dovizi da Bibbiena, a diplomat and man-of-letters who was close to both the pope and Raphael and had links to the Urbino court.

In the spring of 1516, for the spaces that still survive today, the *loggetta* and *stufetta* (respectively, a small porch and a bath), Raphael, who had also been appointed *praefectus* of antiquities by the pope in 1515, reinterpreted the paintings in the Domus Aurea and Hadrian's Villa in Tivoli, which he had visited in April 1516 with his humanist friends, including Baldassarre Castiglione and Pietro Bembo (pp. 78 and 89). The latter, as we know from his correspondence with Bibbiena, who was absent from Rome, conceived the iconographic programme alongside the patron and oversaw the decorative work on his behalf.

In imitation of ancient Roman baths, hot air passed through channels embedded in the walls of the *stufetta*, heating the water that flowed out of the mouth of one of the satyr masks inserted into the marble reliefs attributed to one of Raphael's collaborators, Lorenzetto, who also worked with him in the Chigi Chapel in Santa Maria del Popolo (pp. 76–77). The wall paintings, executed on Raphael's designs by his pupils (in this case mostly Giovanni da Udine and Giulio Romano), depict stories of Venus and Cupid and decorations on red and black grounds in imitation of ancient Roman painting. Prints were immediately made after the paintings (only partially visible today), ensuring the widespread circulation of the mythological scenes.

The *loggetta*, which overlooks the Cortile del Maresciallo, comprises an elongated rectangular space covered with a flat vault due to the terrace above. Its facade is organised in an alternation of wide and narrow bays with arched windows separated by a pair of pilasters, a composition similar to that of the interior walls of Bramante's Belvedere Courtyard.

It was decorated with grotesques on a light ground, and Giovanni da Udine was probably the one tasked with coordinating the work of Raphael's pupils, the hand of one of whom, Polidoro da Caravaggio, is clearly recognisable here. In this space, highly imaginative *all'antica* conceits cover the walls and ceiling, painted with considerable freedom with the aim of using the modern language coined by Michelangelo in the lunettes in the Sistine Chapel to render effects similar to those of Roman *pictura compendiaria*, an "abbreviated", "quick" form of painting.

ROBERTO BERLINI

Stufetta
of Cardinal Bibbiena

Loggetta
of Cardinal Bibbiena

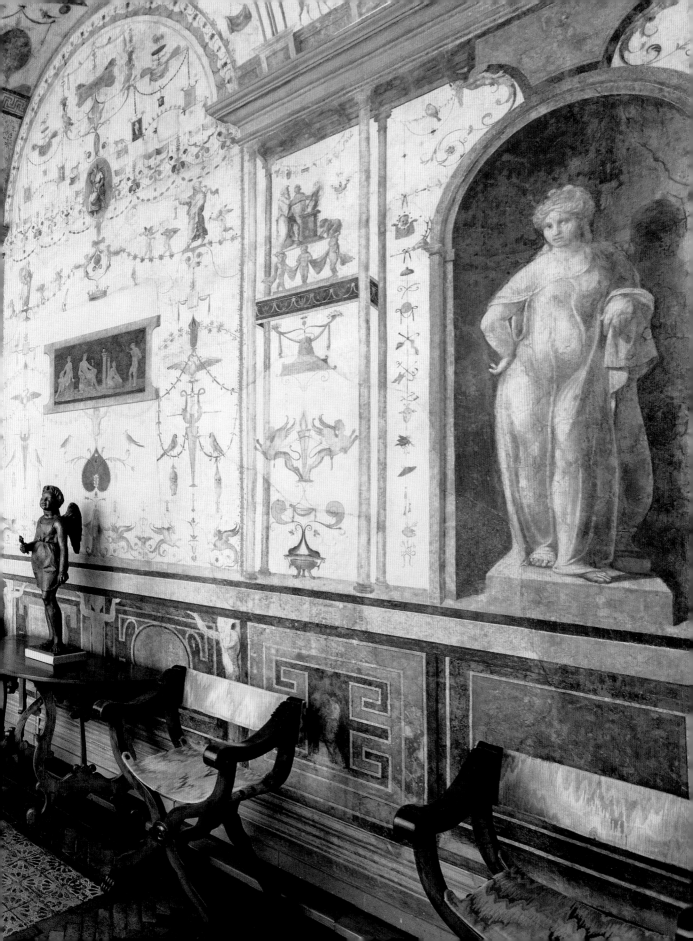

The Sala dei Chiaroscuri

1516–1517
Fresco
Vatican City, Vatican Palaces

The Sala dei Chiaroscuri, also known as del Pappagallo or dei Palafrenie-ri, is located on the second floor of the Papal Palace and was the core of the papal apartments, the room where the pope received guests and ambassadors and held the secret consistory. The decoration, which was heavily reworked by Taddeo and Federico Zuccari in 1560 upon request by Paul IV and then again, a few years later, under Gregory XIII, was designed by Raphael and executed by his workshop between 1516 and the beginning of 1517. Playing on the relationship between real space and fictive architecture, the walls are marked by faux tabernacles hosting monochrome frescoes of life-size Apostles, a motif that was quickly circulated through prints and became widely popular. Among the scant surviving original decoration, we can attribute the *Young St John the Baptist*, painted in monochrome on the fictitious frame of one of the doors, to Raphael.

VALENTINA BALZAROTTI

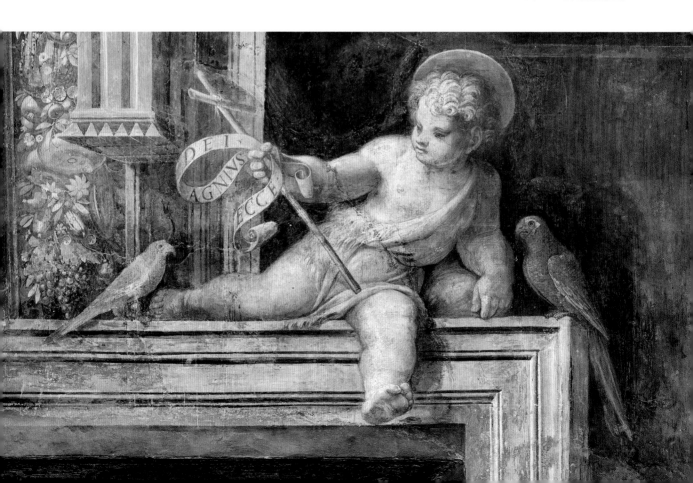

Vatican Loggias

1515 (project)
1518–1519 (painted decoration)
Fresco and stucco
Vatican City, Vatican Palaces

Raphael replaced Bramante as architect of St Peter's in 1514. He was flanked in this role by the older architects Fra Giocondo and Giuliano da Sangallo, although the latter was invested with less authority. In 1515, after both of his colleagues had died, he was asked to not only work on the basilica but also finish the work begun by Bramante inside the Vatican. This included the Loggias on the first and second floors of the papal palace, overlooking the courtyard of San Damaso, part of the pope's apartments, and the loggia on the third floor that was part of the residence of Cardinal Bernardo Dovizi da Bibbiena (pp. 46–49), a personal friend of Raphael. Bramante's work had begun after October 1513, but by 1515 Raphael presented a different project along with a wooden model.

Although in part already effaced under Paul III, the most significant architectural work by Raphael is found in the second loggia, where the famous frescoes of the Vatican Loggias are located. The inner wall presents an alternation of doors and aediculas hosting ancient statues. The alternation of the frames of the niches and of the windows, the blind arch above and the polystyle pilasters give the wall a strong sculptural quality, absent in the loggia below. Each bay is covered by a pavilion vault, the shape of which offers surfaces that lend themselves to decoration, on the model of those of the Colosseum and the Tabularium, and also inspired by Vitruvius's description of the Pinacotheca (picture gallery) in Book VI of his treatise on architecture.

Besides the widely known Vatican Loggias, described above, Raphael designed other loggias on the lower and upper floors.

In the first loggia, at the time accessible even on horseback, Raphael's work includes the seven monumental frames of the interior windows, similar to those of the Temple of the Sibyl in Tivoli, the *all'antica* hexagonal coffers that decorate every three bays of the vault and, most importantly, the dome above the seventh bay, the central one, the decoration of which recalls that of the Chigi Chapel (pp. 74–77).

The third loggia was under construction in July 1517 and also completed in 1519. The noteworthy wooden ceiling, the elegant balustrades of the bays, and the composite architectural order of this loggia are also attributed to Raphael.

FRANCESCO BENELLI

Raphael's work on the Vatican Loggias was not limited to architecture; he designed the decoration as well. Work began on the second floor, completed between 1518 and 1519, because the private apartments of Leo X, located on the same floor as the Stanze, gave onto it. This loggia was reserved for the private use of the pope, who liked to walk there with his guests. Each of the thirteen vaults is divided into four scenes depicting episodes from the Old Testament, with the exception of the last bay, which is decorated with four scenes from the life of Christ. Due to the subject matter, this fresco cycle is also known as Raphael's Bible. Its importance derives from the fact that at this point in his career the artist had not only mastered the language of the ancients but he was also reinterpreting their methods and rules in order to reproduce in a modern manner the spirit and grandeur of their work.

Raphael created not only the stories and designs for extraordinarily inventive decoration and passages of stunning naturalism, he also designed the wooden doors, produced by the Sienese carver Giovanni Barile, and the lost majolica floor, commissioned to Luca della Robbia. In fact, employing an organisational approach that was to become exemplary, he assigned the execution to trusted collaborators. According to Vasari, he delegated to Giulio Romano the supervision of the scenes, which were divided between various assistants, including Giovan Francesco Penni, Polidoro da Caravaggio and Perino del Vaga. But there were numerous artists involved, including some who were not strictly Raphael's pupils, climbing up the scaffolding and contributing to the decoration, at a worksite where the master gave his workshop free reign, an innovative approach that was important for the history of sixteenth-century painting.

The supervision of the embellishment with still lifes, festoons and figures and motifs in stucco was instead entrusted to Giovanni da Udine, undisputed champion of grotesque decoration, who also made use of assistants, including Perino del Vaga, and his work here reached unsurpassed heights for the genre. Just then the Friulian master rediscovered the recipe for white stucco in the ancient style and, showing it to Raphael, was tasked with decorating the intrados, vaults and pillars, taking inspiration from what one could still admire of the decoration of the Domus Aurea and the Colosseum in early sixteenth-century Rome.

While the second loggia was being completed in late spring 1519, Raphael charged Giovanni da Udine with the decoration of the floor below, which was embellished with fictive pergolas filled with a dizzying variety of animals, flowers and fruit and completed by the end of that same year. The decoration of the last floor was interrupted by the death of the artist, but a few of the wooden coffers with the crest of Leo X, designed by Raphael and executed by Barile, still remain.

VALENTINA BALZAROTTI

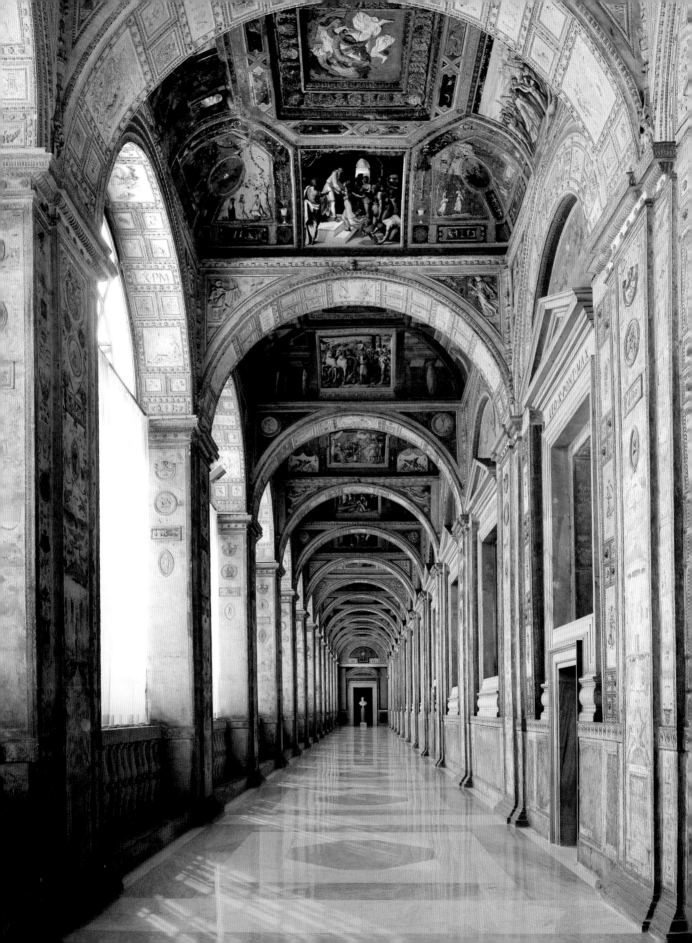

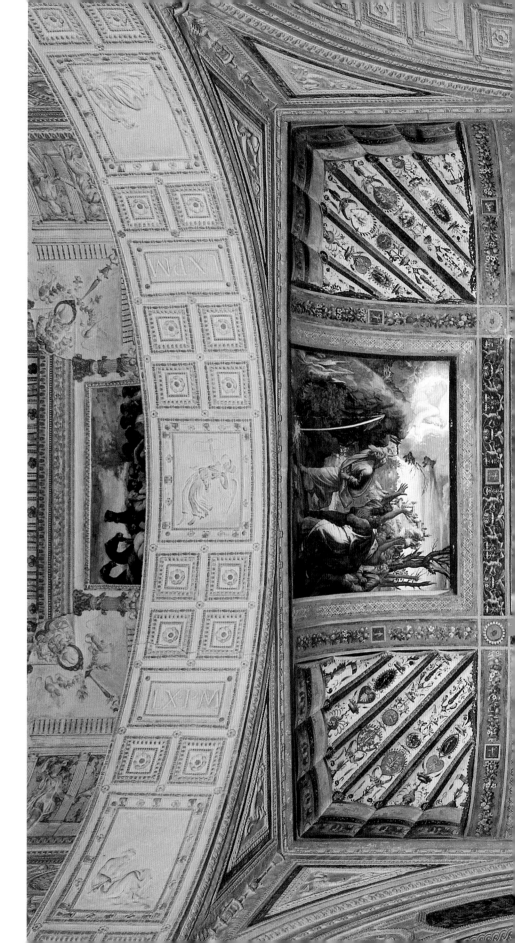

Vatican Loggias,
eighth bay with stories
of Moses and, at the
center, crest of Leo X
in stucco

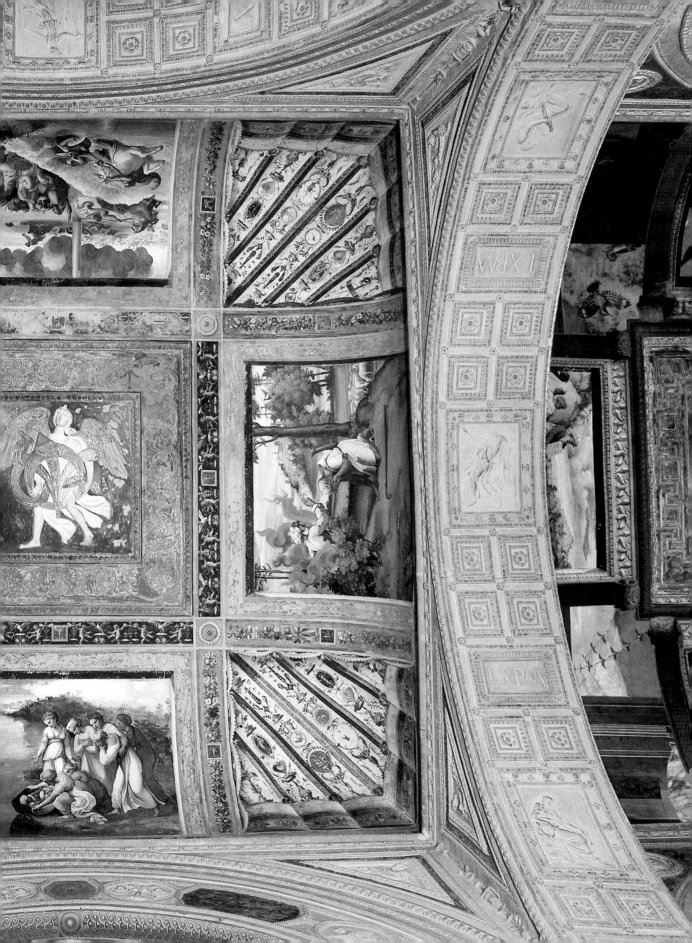

Portrait of a Man

ca. 1502
Oil on wood, cm 46 × 31
Galleria Borghese

The attribution of this small painting remains undecided between Pietro Perugino and Raphael, and debate also continues over the still unspecifiable identity of the sitter. Some have claimed, without real foundation, to see in it the features of Perugino himself or those of Duke Francesco Maria della Rovere or, more plausibly, of the musician, singer and man-of-letters Serafino Ciminelli, known as Serafino Aquilano, present in Urbino at the Montefeltro court at the end of the fifteenth century.

Finely executed in the delicate passages of shadow over the face, the rendering of the sitter's physiognomy, and the black-on-black effects of the fabrics and hair against the blue of the sky, the painting has much in common with Flemish art as it was known between the end of the fifteenth century and beginning of the sixteenth in central Italy and specifically Urbino. Northern European portraiture—particularly appreciated in Italy were Hans Memling's works—played an important role in Raphael's early formation and, during the same period, at the beginning of the sixteenth century, returned as a subject of close study for the older Perugino.

Attributed to Raphael in the collection's eighteenth-century inventories, and then attributed to Hans Holbein, the painting was reattributed to Raphael by the connoisseur Giovanni Morelli. Other scholars, including Adolfo Venturi, instead saw it as the work of Perugino, but, since the overpainting was removed in 1911 (at an uncertain date, the style of the hat was changed and a fur added), the number of scholars supporting the attribution to Raphael has grown.

ADELE MILOZZI

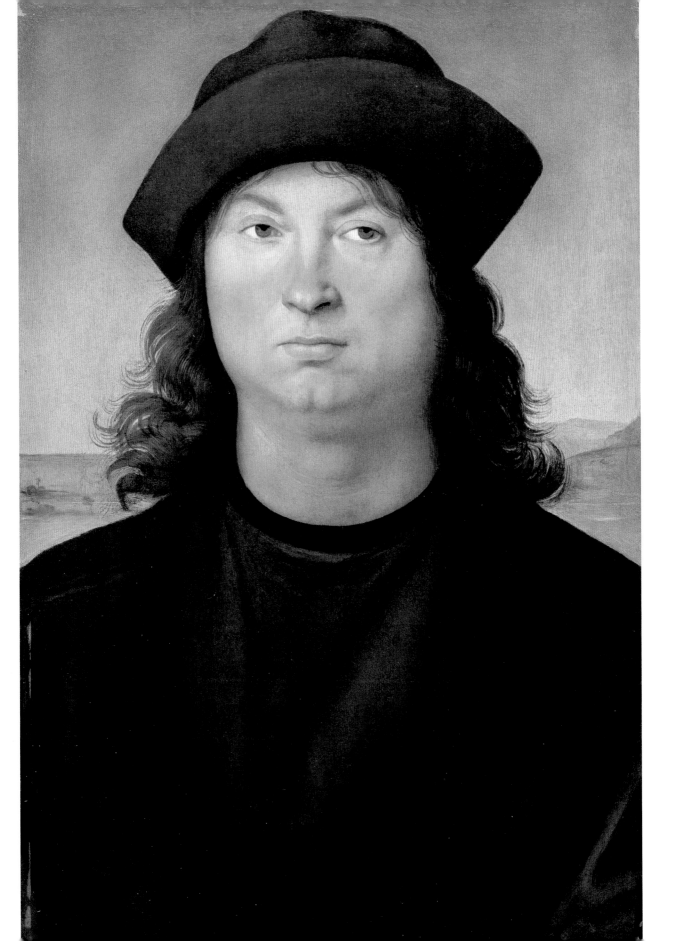

14

Portrait of a Woman (Lady with a Unicorn)

ca. 1506
Oil on wood, transferred to canvas glued to wooden support, 67 × 56 cm
Galleria Borghese

In the nineteenth-century inventories, the painting was attributed to the school of Perugino and described as a St Catherine of Alexandria. It did in fact appear to be so, due to some overpainting, specifically the addition of a mantle and a notched wheel, probably during the first half of the sixteenth century. Between the end of the nineteenth century and beginning of the twentieth, it became clear that the work was a pastiche, due to the lower quality of the hands and the mantle with respect to the finely described face and bust, and a connection with a drawing by Raphael for a female portrait (Paris, Musée du Louvre, Département des arts graphiques, inv. 3882) was discovered.

In 1927, the art historian Roberto Longhi attributed the painting to Raphael, reasserting the theory that a lesser artist active in Florence in the first part of the sixteenth century had later added the parts of the painting that had already been recognised as mediocre: the mantle, the wheel and the hands. A restoration committee (1934–1936) decided to remove the overpainting in order to restore the little dog in the lap of the young woman, which had been revealed in X-rays. But what emerged instead, as we see today, was a unicorn, the result of a change of mind in the midst of work on the painting, replacing the original dog, a symbol of marital faithfulness, with the fantastical animal that could only be tamed by a virgin.

It was therefore a portrait painted for an engagement, datable to around 1506 due to its proximity to portraits from Raphael's Florentine period, first and foremost the *Maddalena Doni* (Florence, Galleria Palatina), which also reveals the influence of Leonardo's *Mona Lisa*, painted shortly before.

The figure recalls Flemish portraiture in the rendering of the clear gaze and the fine hair touched by light, but Leonardo was the source for the way in which the bust, expanded by the large sleeves, rotates and positions itself in space by pivoting on the hands, joined to hold the young, by now tamed, creature.

ADELE MILOZZI

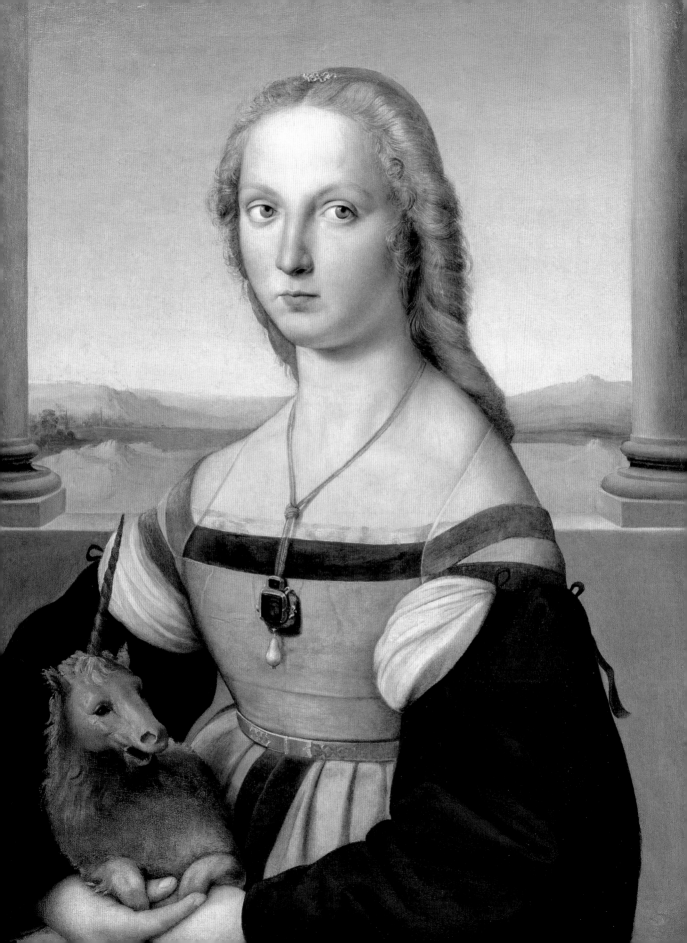

Transport of Christ to the Sepulchre

1507
Oil on panel, 184 × 176 cm
Galleria Borghese

T he subject here is the transport of the body of Christ to his tomb, follow-
ing the deposition from the cross. Marked by the dense intersection of
bodies and gestures and masterly use of colour, the figures are divided
into two groups, that of Christ borne by his carriers, including St John
in prayer, Nicodemus with a yellow mantle, the Magdalene, and the beautiful, strong
youth turned away from the viewer, hair blowing in the wind, on one side, and that of
the Virgin, fainting from sorrow into the arms of the Marys on the other side.

This work, often described as an *Entombment*, was commissioned from Raphael
by Atalanta Baglioni for her chapel in San Francesco al Prato in Perugia, possibly
to commemorate the death of her son Federico, known as Grifonetto, who was as-
sassinated in 1500. Painted in Florence, signed and dated "Raphael Urbinas MDVII",
the painting was stolen in the dead of night on 18 March 1608 on behalf of Scipione
Borghese, nephew of Paul V, who wanted it for
his own collection, and substituted with a copy by
Cavalier d'Arpino (Perugia, Galleria Nazionale).

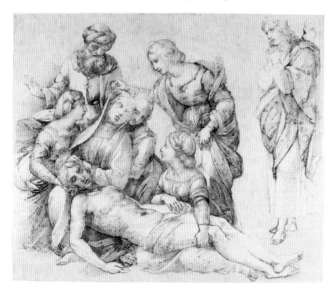

Raphael, *Lamentation
on the Dead Christ*,
1507. Paris, Musée
du Louvre,
Département
des arts graphiques,
inv. 3865r

The altarpiece was completed with a predella
depicting the Theological Virtues, *Hope*, *Charity*
and *Faith*, flanked by putti (Pinacoteca Vaticana,
p. 36). Delicately painted in monochrome, the
figures are staged as if they were statues in niches,
where they project their shadows in a way that
makes them look real. The mild chiaroscuro
makes the bodies appear as if moulded from
wax, depicting them with great refinement and
smoothness.

The complex formulation of the work is docu-
mented in numerous surviving drawings, from
which we learn that at an early stage Raphael in-
tended it to be a *Lamentation*, inspired by the one
by Perugino (Florence, Galleria Palatina)—the influence of which, although mod-
ernised, is preserved in the importance of the landscape and the lively use of colour—
transforming it, however, into a more dynamic subject after studying a sarcophagus
with the *Transport of Meleager* (Rome, Capitoline Museums) and the Florentine
works of Michelangelo, which inspired the interweave of volumes and the arrange-
ment of the figures on diagonals to suggest different planes. The Virgin in the *Doni
Tondo* inspired the seated woman on the right, in a contrapposto position holding up

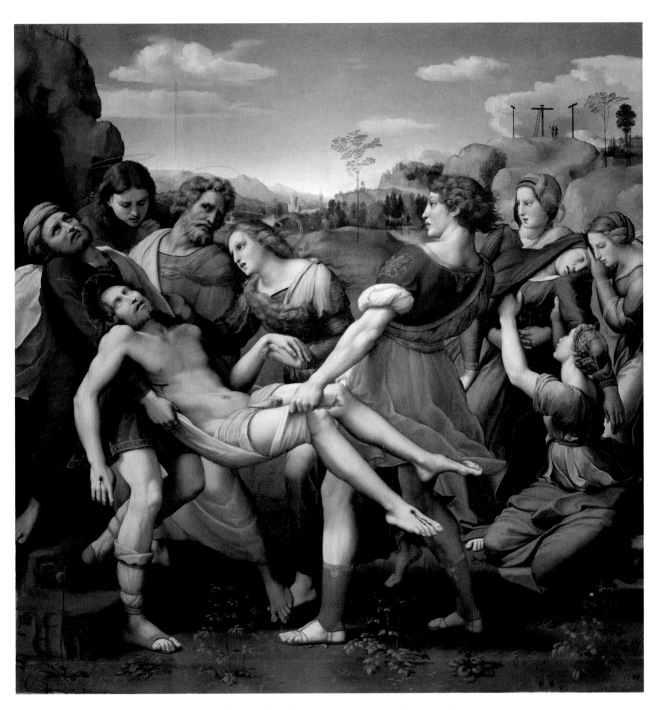

the fainting Virgin, a pose that Raphael developed using a skeleton in a drawing now in London (British Museum, inv. 1895,0915.617). The head of Nicodemus draws on Michelangelo's sculpture of *St Matthew* (Florence, Galleria dell'Accademia), while the muscular tension of the two figures who carry the body of Christ derives from the lost cartoon of *The Battle of Cascina*. The latter was also the source of the sculptural force of the group, arranged to accentuate the three-dimensionality of the composition, immersed in a landscape that owes much to Fra Bartolomeo.

FRANCESCA MARI

16 Sybils and Prophets

1511
Fresco
Santa Maria della Pace, Chigi Chapel

Before commissioning Raphael to paint the *Galatea* (pp. 66–67), the chapel of Santa Maria del Popolo (pp. 74–77), and the Loggia of Psyche (pp. 68–69), Agostino Chigi involved him in the planning of his family chapel in Santa Maria della Pace, where all that remains *in situ* is the fresco decoration. The sculpture apparatus, which dates to the seventeenth century (1656–1658), was initiated by the Chigi pope Alexander VII and completed, under the direction of Pietro da Cortona, by Ercole Ferrata, Cosimo Fancelli and Antonio Raggi.

The absence of documentation prevents us from establishing when the Sienese banker might have acquired patronage of the chapel. The chronology of the paintings is much debated, but according to the most recent scholarship, the execution must date to 1511 on stylistic grounds, between the completion of the decoration of the Stanza della Segnatura and the beginning of work on the Stanza di Eliodoro, which is to say during an initial period of close contact with Michelangelo's work on the Sistine Ceiling, the first part of which was unveiled in the summer of 1511. Evidence of this influence is clear in the volume of the figures, bound in a kind of garland as in the *Parnassus* and the *Virtues* of the Segnatura (p. 22), with increasing proximity to the forms of ancient sculpture, which is especially evident in the magnificent preparatory drawings. As reported in Vasari's *Lives*, Raphael requested assistance with the execution of these frescoes from his friend, also from Urbino, Timoteo Viti, who was indeed absent from Urbino during 1511 and whose hand can be identified in the *Prophets* in the upper part and the flying angel on the right in the lower part. The corresponding angel on the left, the *Sybils*, the angels and the winged putti are all unquestionably by Raphael. The figures were set within fictive architecture that is still clearly visible in the large lunette but was covered up in the lower register in the seventeenth century. The Greek and Latin inscriptions, drawn from scriptural sources, classical authors (Virgil) and apologetic texts (Lactantius) allude to the theme of resurrection, the keystone of the chapel's decoration. The seventeenth-century additions partly altered the unified conception of the space, which must have also included the painting intended for the altar, for which we have some drawings by Raphael for a *Resurrection* (never realised), and the ornamentation. Graphic evidence that can be traced to the circle of Raphael indicates that beneath the *Sybils* there were to be two medallions in the space now occupied by the marble putti that hold up the symbols of the Passion, identifiable, in all probability, as the two bronze tondi documented, already in the early 1570s, in the Milanese abbey of Chiaravalle. The reliefs, likely commissioned towards the end of

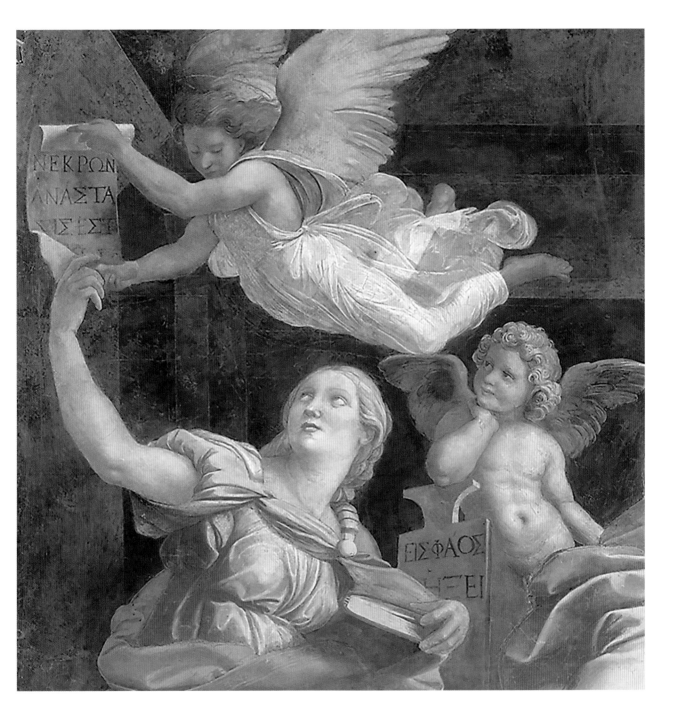

1510 from the goldsmith Cesarino da Perugia based on designs by Raphael, depict *Christ in Limbo* and *Doubting Thomas*, two subjects suited to the visual programme conceived for the chapel. In December 1520, after the deaths of Raphael and Agostino Chigi, Sebastiano del Piombo was commissioned by the executors of Agostino's will, to paint an altarpiece depicting the *Resurrection*. The agreement was renewed ten years later, but the painting was never made.

ALESSANDRA CAFFIO

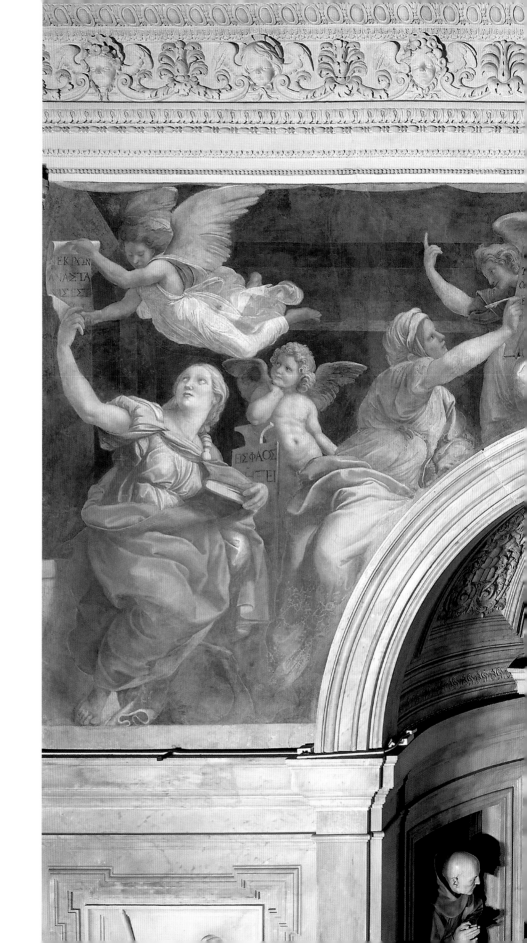

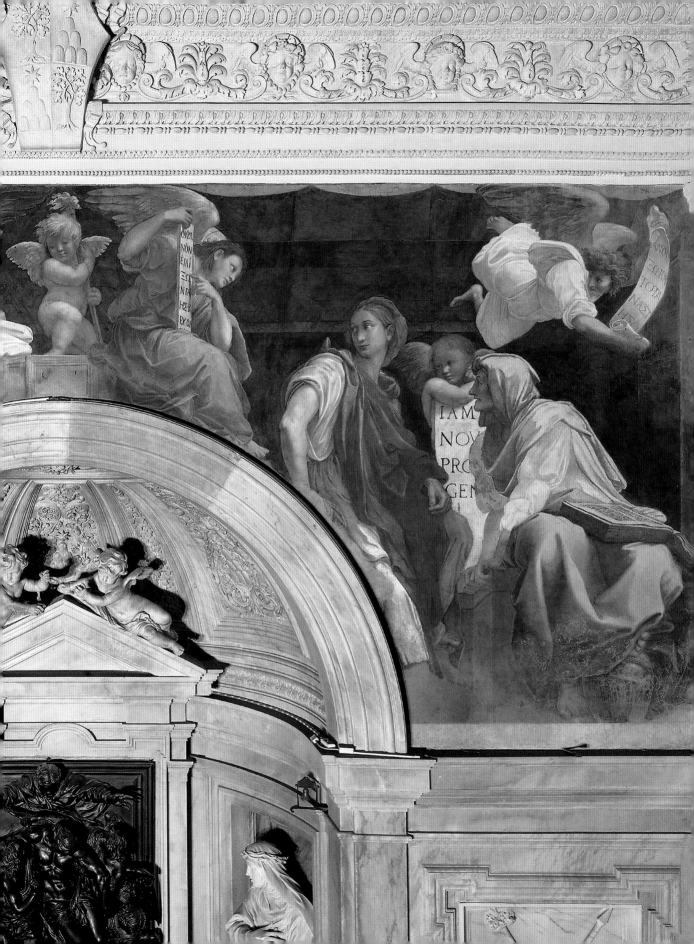

17 Galatea

1512
Fresco
Villa Farnesina

The Sienese Agostino Chigi, banker to popes Julius II and Leo X, decided to build, on designs by Baldassarre Peruzzi, a suburban villa, now called the Villa Farnesina. Construction began in 1506 and, immediately after, the villa was embellished with a lavish decorative programme.

The vault of the loggia on the Tiber, known as Loggia di Galatea due to Raphael's painting, was frescoed by Peruzzi in 1511 with the patron's horoscope, and decoration of the lunettes immediately followed, depicting scenes from Ovid's *Metamorphosis* by Sebastiano del Piombo, who had arrived from Venice with Chigi.

Shortly after, Sebastiano was commissioned to fresco a *Polyphemus*, and Raphael the adjacent *Galatea*. The giant is in the grip of his unrequited love for the nymph, who he sees passing over the sea with her court of Nereids and Tritons, following the text of Philostratus's *Imagines*, in which the ancient writer described a fictitious painting depicting this subject. Rooted in the humanistic interests of the circle of Agostino Chigi, whose purpose in evoking the painting of the past might have been to compare the styles of the two modern painters, this decoration pushed Raphael to grapple anew with ancient statuary (numerous citations are drawn from the *Belvedere Torso*), as well as with Michelangelo's painting and sculpture, as is clear in the figures surrounding Galatea. The young woman, caught in a whirl of wind that blows her deep-red mantle, like in Philostratus, stands in the middle of the composition. The twist of her body, with her leg bent and face turned in one direction while her arms are turned in the other, triggers the rotating movement that pervades the scene, drawn from Leonardo's *Leda*, which Raphael had seen in Florence and had already reinterpreted a few years earlier in his *St Catherine* (London, National Gallery), but here revisited in the light of Michelangelo's Sistine Ceiling. The physiques with prominent muscles, the tightening of the bodies in motion and the complex dynamism of the composition tally with the *Expulsion of Heliodorus from the Temple* (pp. 24, 26), painted by Raphael at the Vatican in 1512, which serves as a reference for the dating of *Galatea*.

FRANCESCA MARI

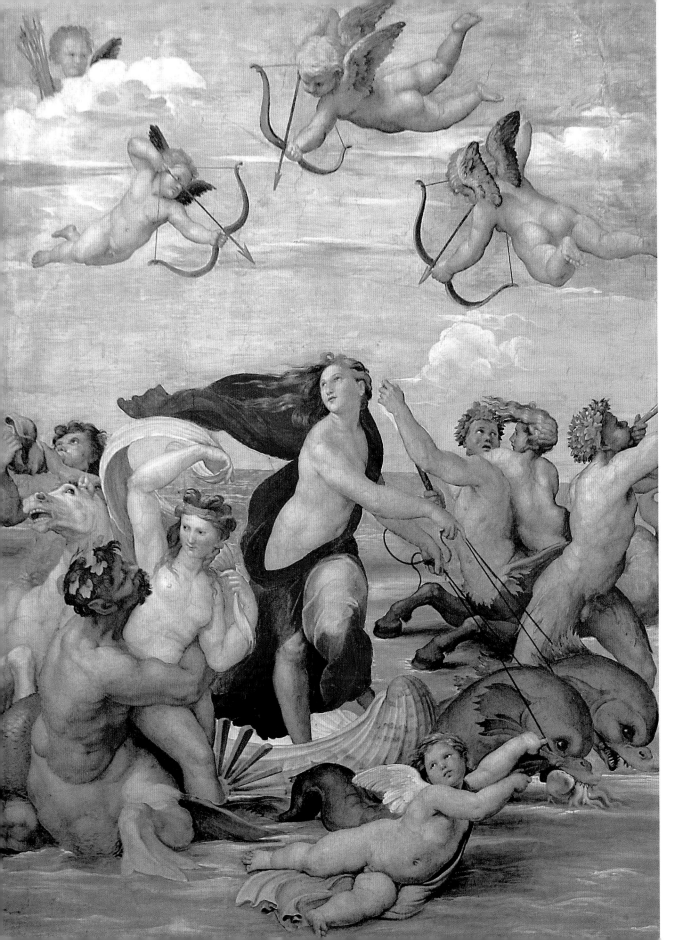

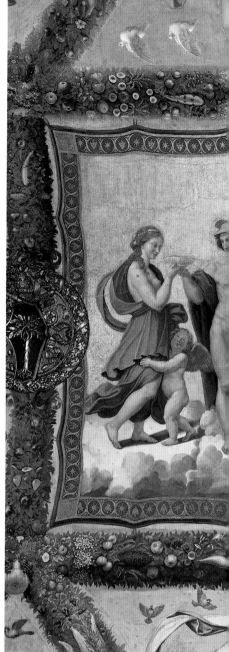

18 · The Loggia of Psyche

1517–1518
Fresco
Villa Farnesina

Raphael was commissioned to decorate the Loggia of Psyche, which served as the main entrance to the suburban villa of Agostino Chigi, for the wedding of the Sienese banker and the young Francesca Ordeaschi in 1519. The frescoes, unveiled in January of that year, illustrate episodes from the story of Cupid and Psyche as told by Apuleius in the ancient Latin novel *The Golden Ass*. The story unfolds against a fictive sky in the pendentives and webs of the ceiling, divided in a way that echoes the models of ancient Roman ceilings, decorated with foliate and floral festoons that include fruit and plants that had just been introduced from the New World. This lush fictive pergola, which must have created an illusion of continuity with the outdoors when the loggia was open onto the garden, was the work of Giovanni da Udine (the student of Giorgione, according to the sources), as were the beautiful animals that populate the ceiling, including the vast variety of birds that rework ancient Roman wall painting in a modern style, with intense naturalism and free brushwork.

In the middle of the ceiling, two fictive tapestries hung to simulate *all'antica* velaria depict the *Presentation of Psyche to the Gods* and the *Wedding Banquet of Cupid and Psyche*. This iconography created the suggestion that Agostino Chigi's villa was the palace of Love and his wedding comparable to the one in the myth.

The narrative begins on the short side, where *Venus Points out Psyche to Cupid*, and continues clockwise: *Cupid Instructing the Maidservants*; *Venus Complaining to Ceres and Juno*; *Venus Flying on her Chariot to Olympus*; *Venus Beseeching Jupiter for his Help*; *Mercury Announcing a Reward for the Finder of Psyche*; *Psyche Holding Proserpina's Miraculous Ointment*; *Psyche Bringing Water from the Styx to Venus*; *Jupiter Acquiescing to Cupid's Pleading*; *Mercury Leading Psyche to Olympus*.

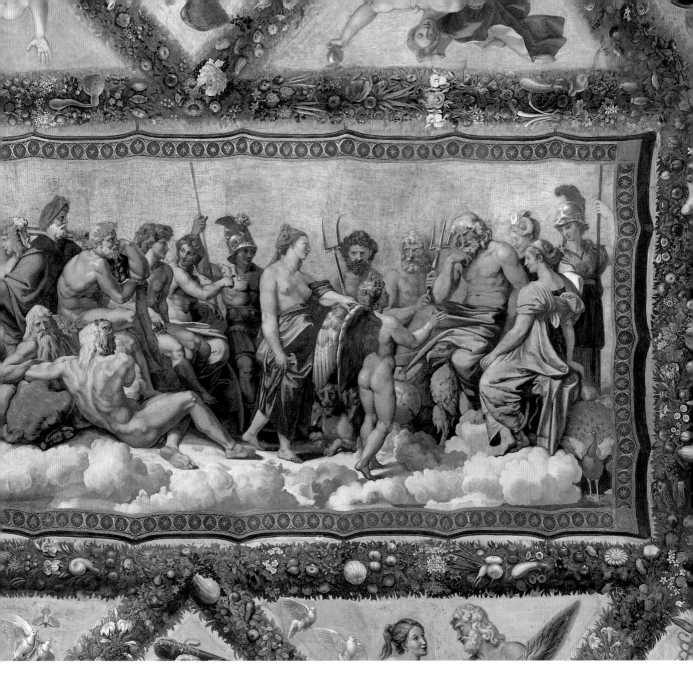

Raphael made drawings for all of the decoration, originally planning to also paint the lunettes and walls, which only ended up being decorated much later on, and left almost all of its execution to his students, in particular Giulio Romano, but also Giovan Francesco Penni and Giovanni da Udine. Some of the figures in the central scenes and on the side towards the garden were repainted by Carlo Maratti at the end of the seventeenth century, as part of an extensive restoration that aimed to preserve this major monument of the style of Raphael, celebrated at the time by classicizing culture.

CAMILLA COLZANI

The *Presentation of Psyche to the Gods*

Chigi Stables

1513–1520
Villa Farnesina

Opposite:
Anonymous, French, half front elevation and end elevation (top) and detail with the plan (bottom), early to mid-16th century. New York, The Metropolitan Museum of Art, 49.92.50 and 49.92.44

The Chigi Stables are on the grounds of the Villa alla Lungara, now called the Villa Farnesina and built by Agostino Chigi, the fabulously wealthy banker to Alexander VI, Julius II and then to Leo X. Construction of the stables was entrusted to the master builder Giovanantonio Foglietta da Milano, who would go on to also build Palazzo Jacopo da Brescia (pp. 84–85), and began in about 1513, concluding on 28 February 1520, just before Raphael's death. Almost entirely demolished in 1808, all that survives today is the lower part of the ground floor on the Via della Lungara side and a fragment of the short side to the north. The stables were attributed by Vasari to Raphael, who designed them almost at the same time as the chapel for the same patron in the church of Santa Maria del Popolo (pp. 74–77) and about a year after the loggia which was used for banquets and located between the villa and the banks of the Tiber. A few drawings survive that allow us to reconstruct the original appearance of the stables. An elongated, irregular rectangle in plan, the building had three floors and a basement. The ground floor was divided into three "aisles" that housed forty-two horses in compartments placed laterally to the central corridor. The first floor was used as apartments for Agostino's guests, and the uppermost floor comprised a mezzanine or attic, possibly used as lodging for personnel.

The building was made out of inexpensive materials that can still be seen today: pilasters in brick masonry and tufa panels made up of irregular pieces, meant to be covered with plaster to create the impression of marble, while exposed stone was limited solely to the peperino capitals and bases. The Via della Lungara side was divided into seven bays separated by pair of pilasters, Doric on the ground floor, Corinthian on the first floor and abstract, which is to say without bases or capitals, on the mezzanine, following proportional criteria close to those in Vitruvius's treatise on architecture. On the ground floor, they framed blind panels, which were substituted by windows with balustrades on the first floor, in an essentially simplified variation of the corresponding floor of Bramante's Palazzo Caprini (**fig. 6**).

FRANCESCO BENELLI

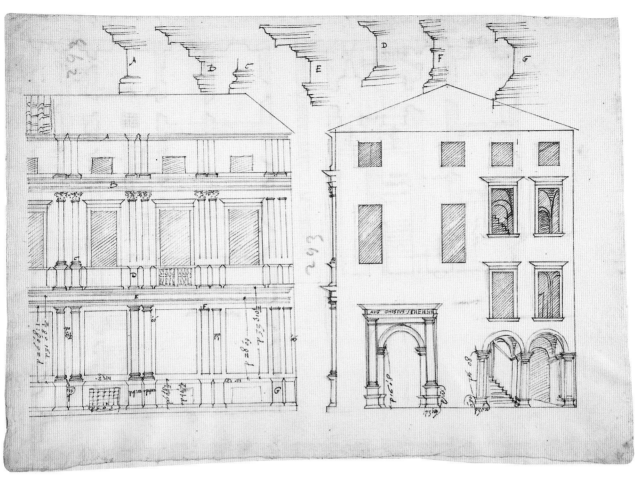

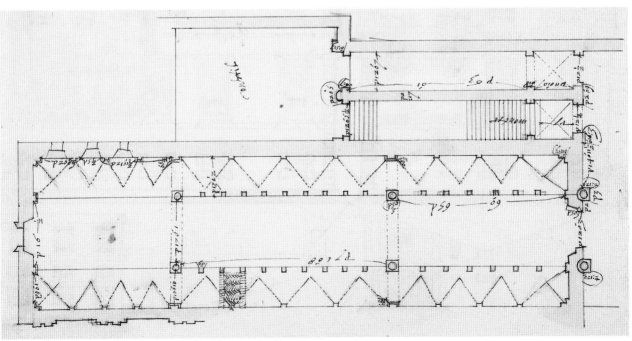

71

20 Isaiah

Fresco
1513
Sant'Agostino

The powerful figure of the prophet holding a scroll with the Hebrew inscription "Open the gates, so that the righteous nation that keeps faith may enter in" (Isaiah 26:2) is accompanied by two putti holding an ansate tablet with the dedication, written in Greek, by the patron, the papal protonotary Johann Goritz of Luxembourg: "To St Anne, mother of the Virgin, to the Holy Virgin, mother of God, to Christ the Saviour, Johann Goritz". As indicated by a similar dedication, in Latin, the sculpture representing the *The Virgin and Child with St Anne* below the fresco, where Goritz wanted his tomb, was carved by Andrea Sansovino in 1512. On that occasion, humanists and men-of-letters, bound in a kind of academy to the patron, called Coricio in Latin, posted poems for the consecration of the altar.

Often held to be contemporary to the sculpture, the *Isaiah* instead dates for stylistic reasons to 1513, the height of the artist's reaction to Venetian painting, around the time of the *Meeting between Leo the Great and Attila* (pp. 25, 27–28), when Raphael was rereading the work of Michelangelo on the recently completed Sistine Ceiling, the clear influence of which is seen in the monumental forms and the contrapposto of the figures. The position of the legs derives from the ancient statue of the *Jupiter Ciampolini* (Naples, Museo Archeologico Nazionale).

We can suppose that the fresco was painted in celebration of the election of Giovanni de' Medici to the papal throne in March 1513, alluded to in the inscription displayed by Isaiah. With the movement of the figure, caught in the gesture of unrolling the scroll, his mantle still billowing, the prophet is represented as if he has just arrived with the psalm's announcement of peace. Leo X, viewed as a guarantor of peace and prosperity by the humanists, was celebrated as such in the writings of Egidio da Viterbo, general of the Augustinian Order, who participated in the conception of this altar for his church. Egidio's vast culture and taste for syncretism are behind the fresco's inscriptions in various languages and the multiple references to ancient texts and pagan, Jewish and Christian writings that tied it to the sculpture. The most important reference, although implicit, is to the *Fourth Eclogue* of Virgil's *Bucolics* in which the Cumaean Sibyl prophesies the advent of a happy age brought by a *puer*, a prophesy then understood to concern the Christ Child. Like a standard, the fresco celebrating Leo the Peacemaker, Lorenzo the Magnificent's son, thus linked itself to the pre-existing sculpture group announcing the dawn of a new era.

SILVIA GINZBURG

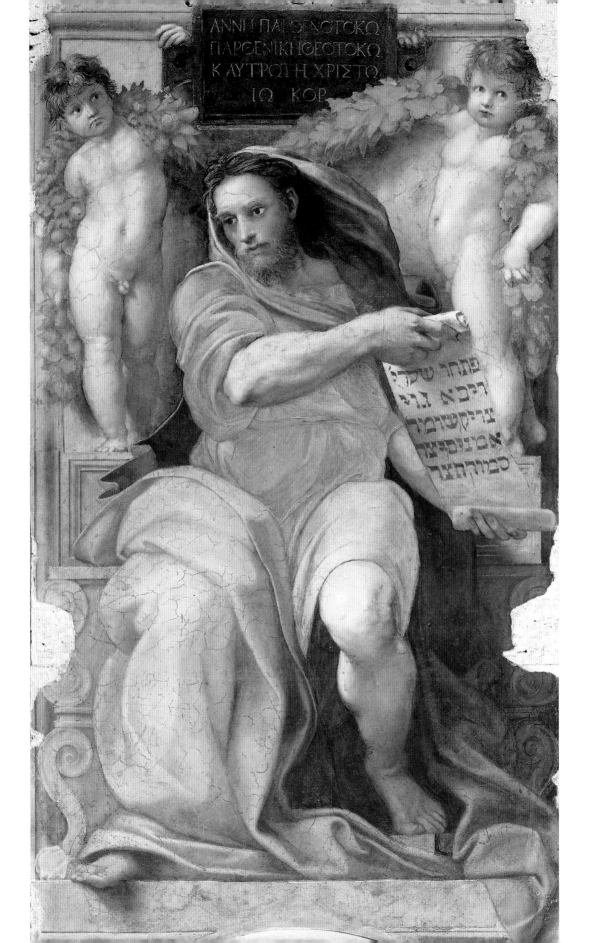

Chigi Chapel

1511–1513 (architectural plan)
1513–1516 (mosaics of the dome)
Santa Maria del Popolo

Agostino Chigi's interest in having a funerary chapel built for himself and his family members in the basilica of Santa Maria del Popolo dates to about 1507. The church was favoured by Julius II and entrusted to the Augustinian order, with which the Chigi family had long been linked. In 1507, the Sienese banker acquired a fifteenth-century chapel which he immediately demolished in order to build a grander, more magniloquent one. His will of 1519 is the first document that attests to Raphael at the worksite, but construction had begun years before, since by that date the chapel was already at a good point. The dome was in fact completed in 1516 and we can imagine that the plan was drawn up between 1511 and 1513. Agostino and Raphael died within five days of each other in April 1520, when the structural aspect of the chapel and the dome decorations were nearly complete, but the rest of the decoration and the tomb monument had yet to be realised. It was necessary to wait until 1652, when Fabio Chigi, the future Alexander VII, became cardinal, for the installation of the altar and completion of the sculptural decoration, entrusted to Gian Lorenzo Bernini and Alessandro Algardi.

The chapel, tucked between the left side of the church and the city walls behind, and so barely visible from the outside, was not in want of decoration. It is reached from the left aisle of the church, stepping through a portal that reproduces, on a smaller scale, the system of pilasters of the arch framing the entrance to the Pantheon, which was also the source for the bases and capitals. Inside, we find ourselves in a centralised space probably inspired by the Medici Chapel in the church of San Lorenzo in Florence, designed at the end of the 1410s by Filippo Brunelleschi.

The Chigi Chapel has an octagonal plan with shortened diagonal sides that, fitted with fluted Corinthian pilasters and a central niche, serve as pseudo-structural elements, immediately calling to mind the massive pillars, under construction since 1506, of Bramante's crossing for St Peter's, which also support pendentives with tondi. The long sides, emphasised by arches, are reserved for the altar and the pyramidal tombs of Agostino and his brother Sigismondo. At the same time, being slightly sunk into the wall, they create an impression of being in the middle of a bigger space, a sensation that is lessened today by the seventeenth-century addition of the trabeation, which crosses over them in continuity with that of the pilasters. The arches and pendentives visually support a further trabeation that introduces a drum perforated by eight windows, the sole sources of natural light.

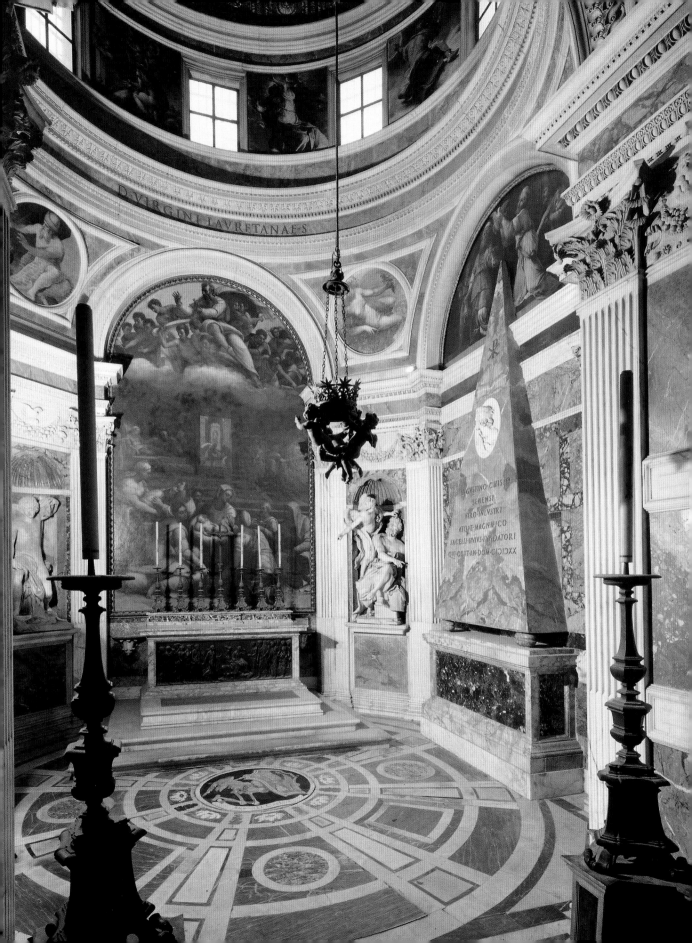

The hemispherical coffered dome above was designed by Raphael with an exposed extrados, a feature that was, however, lost in later restorations.

For this space, Raphael contrived an innovative space-time device: visitors, entering the church that had been completed about thirty years before, found themselves in a contemporary architectural space from which, crossing a clearly *all'antica* portal imitating that of the Pantheon, they entered a room—the chapel—that instead anticipated Bramante's St Peter's, then under construction, the structure of which was at the time barely perceptible, hence anticipating a future building. The rich variety of materials used for the chapel—Carrara marble, ancient and modern polychrome marble, bronze—was sculpted and finished with utter refinement. The marble, frescoes and mosaics together constitute a whole organised in accordance with precise proportional relationships, recreating the opulence of the interior of the Pantheon and making the Chigi Chapel the first example of a Renaissance *Gesamtkunstwerk* (total work of art), consonant with the stature of the patron and a model for numerous future noble chapels.

FRANCESCO BENELLI

The decoration of the chapel began with the mosaic in the central part of the dome and was executed in 1516 by the Venetian Luigi de Pace on designs by Raphael, some of which have been preserved. The eight panels, divided by gilt stucco ornament, depict seven planets in their personifications as pagan deities, accompanied by angels and the symbols of the zodiac. In the middle of the dome, a heavily foreshortened, nearly full-length, powerful God the Father looks down as if entering through an opening in the cupola, similar to that of the Pantheon, against a blue sky, perhaps to call the Virgin to him. *Our Lady of the Assumption* was probably the subject originally intended for the altarpiece, which then became the *Birth of the Virgin* later painted by Sebastiano del Piombo.

The original plan was for the mosaic to continue between the windows of the drum and in the tondi on the pendentives. These areas depicting stories from Genesis and allegories of the Seasons were instead decorated in paint much later. After Raphael's death, the heirs of Agostino Chigi had commissioned them to Sebastiano del Piombo, renewing the commission in 1530, along with the altarpiece depicting the *Birth of the Virgin,* now on the altar, in oil on peperino, but the frescoes were not begun until 1552, the project having been taken over by Francesco Salviati, who also worked on the *Birth of the Virgin,* which had been left partially incomplete when Sebastiano died in 1547.

Raphael entrusted the chapel's sculptures to his collaborator Lorenzetto (Lorenzo Lotti), providing him with the drawings. By 1523, Lorenzetto had executed the statue of *Jonas*, to the left of the altar, inspired by the ancient sculptures of the *Putto Riding a Dolphin* (Rome, Galleria Borghese) and the *Farnese Antinous* (Naples, Museo Archeologico Nazionale), and had begun the *Elijah,* which was completed by his student Raffaello da Montelupo between 1523 and 1527. In 1521, Raphael and Agostino Chigi having both died, the brother of the latter, Sigismondo, commissioned Lorenzetto to also sculpt two funerary monuments in the shape of pyramids, along with bronze reliefs; of the latter, the only one that has been preserved is a frieze, later placed on the altar, depicting a *Christ and the Samaritan* that reinterprets the

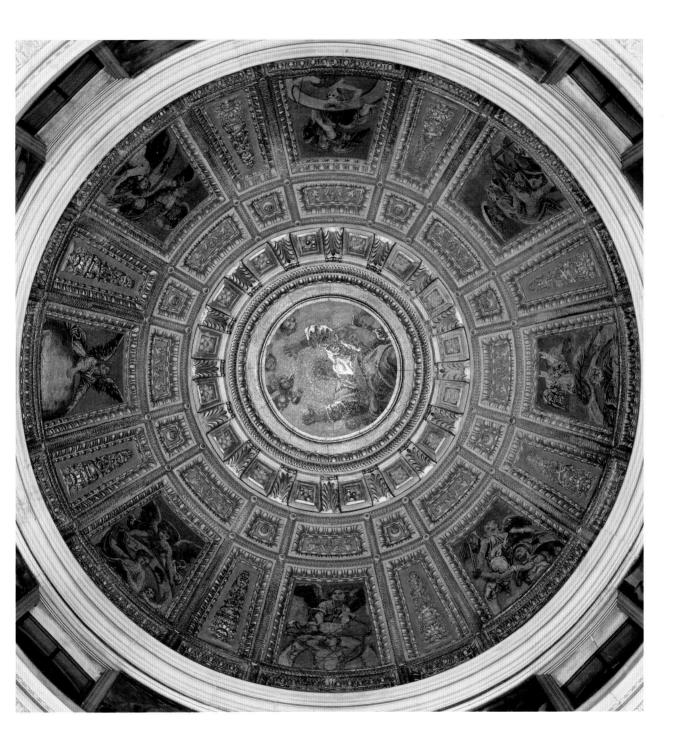

ancient marble relief known as the *Borghese Dancers* (Paris, Musée du Louvre). Lorenzetto only executed one of the tombs for Agostino and Sigismondo, as well as the base for the other, but they were completed by Gian Lorenzo Bernini, along with the statues of *Daniel* (1655–1657) and *Habakkuk* (1656–1661), commissioned by Pope Alexander VII.

FRANCESCA MARI

Portrait of Andrea Navagero and Agostino Beazzano

1516
Oil on canvas, 76 × 107 cm
Rome, Galleria Doria Pamphilj

This double portrait was identified as the one described by the sixteenth-century connoisseur Marcantonio Michiel in the Paduan residence of the Venetian Pietro Bembo, celebrated man-of-letters and friend of Raphael, as "the painting on panel of Navagero and Beazzano, by the hand of Raphael of Urbino", evidently one of the many instances of a painting on canvas applied on a wooden support. Given by Bembo to Beazzano in 1538, it entered, after various other changes in ownership into the collection of Cardinal Pietro Aldobrandini and, finally, that of Olimpia Aldobrandini Pamphilj, a core collection in the gallery where it is preserved today.

The features of the two Veneto humanists Andrea Navagero and Agostino Beazzano, both friends of Bembo, are described with stylistic choices that draw on different painting traditions. Navagero, on the left, was painted in the Venetian style, as expressed by the quick rendering of the luminous folds of the velvet sleeve, the shadows that conceal part of the face, the shine on the forehead and the way in which the sitter was captured in the typically Venetian and powerfully naturalistic "shoulder" pose, as if he had just been asked to turn towards us. The rendering of Beazzano, on the right, was instead conceived and executed as a central Italian portrait, with the three-quarter pose, wide sleeve invading the foreground, more fully lit face, and gaze again turned towards the viewer.

The pair is documented in Rome in early April 1516 in a letter from Pietro Bembo to their common friend, Cardinal Bibbiena (p. 46), in which he announces an upcoming trip to Tivoli that they will be taking together along with the man-of-letters Baldassarre Castiglione and Raphael, to see the ruins of Hadrian's Villa as well as more recent things: "We will see the old and the new, and all that is beautiful in the district", Bembo wrote.

Navagero returned to Venice shortly after, information that allows the portrait to be precisely dated. It is uncertain whether it was commissioned from Raphael by Bembo to remember the two friends, or by one of the two sitters, or by both as a gift for Bembo, or perhaps owned by Navagero and then acquired by Bembo when he died in 1529. Of course, by evoking, with extraordinary imitative force and the compositional devices noted above, the physical presence of those who are far away and past conversations, the work became a concrete representation of the circular bond of affection, in the spirit of humanist friendship, between the owner of the painting and the two sitters, as well as the painter.

SILVIA GINZBURG

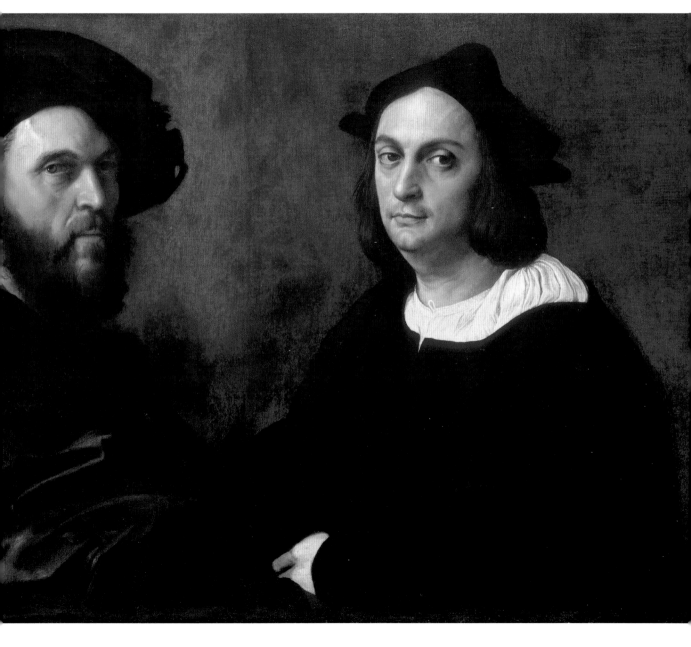

23 La Fornarina

ca. 1517–1520
Oil on wood, 85 × 60 cm
Gallerie Nazionali di Arte Antica, Palazzo Barberini

One of the first paintings to enter the Barberini collection in the early seventeenth century, it came from the collection of the Sforza di Santafiora and has traditionally been identified as a portrait of a woman loved by Raphael. The young woman is depicted semi-nude, with her arms in the pose of the ancient statue of the *Venus Pudica*, against a myrtle bush, sacred to Aphrodite, and a quince branch, symbol of fertility. This background replaced an earlier view of a landscape, which an X-ray revealed opened up behind a parapet. The original landscape, the current vegetation and the conception of the figure reference the work of Leonardo, who was in Rome from 1513 to 1516 and had executed a now lost painting, which can be reconstructed from copies, that depicted the woman loved by Giuliano de' Medici nude.

While the portrait by Leonardo probably made reference to the passage in Pliny's *Naturalis Historia* that tells of how Alexander the Great had asked the painter Apelles to paint a nude portrait of his concubine Campaspe, Raphael's painting seems to refer instead to the second part of the story: realising that the painter had fallen in love with the young woman, Alexander gave her to Apelles, who then painted her again as his own lover, Venus Dionea, the Earthly Venus.

The identity of the sitter remaining uncertain (held by some to be the daughter of a Sienese baker who lived near Via della Lungara), and imagining her as the Campaspe of Raphael, the new Apelles, we might ask whether, sticking with Pliny's model, the patron, who in this case would have played the role of Alexander the Great, might have been Agostino Chigi who, according to Vasari, seeing that Raphael was leaving his work on the Loggia of Psyche (pp. 68–69) for amorous trysts, permitted the artist to live with his beloved in order to get him to finish his work.

The painting is datable for stylistic reasons between 1517 and 1520. In spite of the contrast between the refined subtlety of the rendering of the torso, arm and veil and that of the face, which has a cruder naturalism, it does not seem to be attributable to Giulio Romano, as some scholars have argued.

CAMILLA COLZANI AND SILVIA GINZBURG

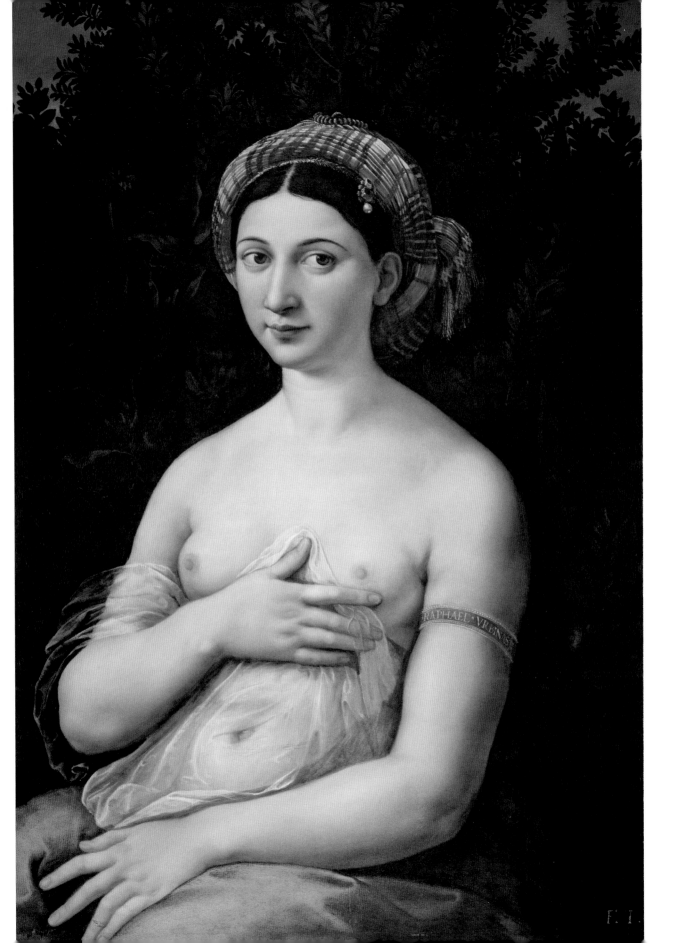

Sant'Eligio degli Orefici

1509–1516 (architectural plan)
Via di Sant'Eligio 9

The church was designed by Raphael for the Corporation of the Goldsmiths, founded in 1508 and composed primarily of Tuscan members, who decided to build it upon the organisation's founding. Attribution to Raphael is based on an inscription in a survey drawing of the plan of the church (Uffizi 635 Ar) by Sallustio Peruzzi. Built on a lot previously occupied by the medieval church of Sant'Eusterio, it was designed starting in 1509 and before 1516. In 1522, two years after the death of Raphael, the worksite was probably taken over by Baldassarre Peruzzi, who modified the original plan for the parts that had not been built yet and designed the lantern above the dome, construction of which began in 1526. The rest of the work, from the upper part of the walls up, proceeded very slowly and was drastically altered by Flaminio Ponzio, whose changes were completed at the beginning of the 1620s and included the current facade.

The original plan was in the form of a Greek cross—and not the current inscribed cross—with a facade covered at least in part with travertine and correspondent to the width of the front arm. This plan, entirely new in Renaissance Rome, evoked Tuscan precedents such as Santa Maria delle Carceri in Prato (under construction since 1485), designed by Giuliano da Sangallo, with whom Raphael shared the appointment of architect of St Peter's precisely between 1514 and 1515. The typical Florentine two-tone interior, created by the contrasting grey-painted Doric architectural order and white walls, together with the short diagonal cut of the four interior corners framing the central space—echoing Bramante's large pillars for St Peter's—lend a Tuscan aspect to the architecture that was evidently favoured by the patrons. Raphael's original design for the facade was characterised by a Doric order with trabeation complete with triglyphs and metopes and a large Serlian window. Raphael inserted both the Doric order and the window in the building painted in the fresco of the *Fire in the Borgo* (pp. 30–33), contemporary to the project of the church.

FRANCESCO BENELLI

Palazzo di Jacopo da Brescia

1514–1519
Via Rusticucci 14

The building that exists today is a nearly faithful reconstruction, in part using the original materials, of two of the three original facades, demolished in 1936, built on the adjacent via Alessandrina, at the time a prestigious street and coveted location for illustrious residences. The attic and especially the interiors have instead been radically altered, although their original appearance is known through drawings and surveys made prior to the demolition.

Jacopo da Brescia was the personal physician of Leo X, who sold him the land in 1514. The worksite was entrusted to the master builder Giovanantonio Foglietta of Milan, who had already built the Chigi Stables (pp. 70–71), and work was completed in 1519. There are no documents attributing the design to Raphael, but he was the only one capable of conceiving such a building in the years immediately following Bramante's death. The plan is trapezoidal in shape and hence difficult to divide, but the architect did so with masterful skill, finding a way to make use of every scrap of space. A narrow atrium leads to a small courtyard from which you access a stair, which occupies the only triangular space in the building so that the other spaces could be somewhat regular in shape. On the front side, the upper floor has three rooms, the middle one a large salon and the one to the west previously home to the owner's office. At the back, the rooms are more irregular and were used as service spaces, such as the kitchen.

The facade is regularly divided following a scheme taken once again from Palazzo Caprini (fig. 6): a lower floor decorated with pseudo-isodomous rustication in rough peperino, which is to say an alternation of taller and shorter bands, and no vertical gaps, increasing the sensation of the building's length. The upper floor is marked out by Doric pilasters placed on smooth semi-pilasters, which frame windows with alternating triangular and curved gables, similar to the aediculas in the Pantheon. Vitruvian Doric trabeation identical to that planned for the facade of Sant'Eligio degli Orefici (pp. 82–83) separates the upper floor from the attic, which is complete with abstract pilasters, like the Chigi Stables. The short side to the west, which has no windows at this level, was treated like a triumphal arch and clearly expresses the importance of the revival of ancient monumental motifs, typical of the taste of Leo X and his court.

FRANCESCO BENELLI

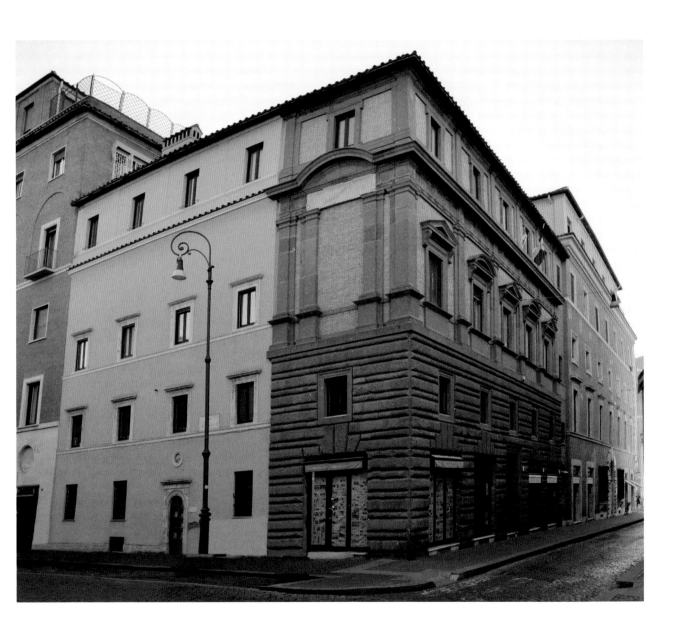

Palazzo Alberini

Before 1515 (architectural plan)
Via del Banco di Santo Spirito, 12

The Roman nobleman Giulio Alberini, agricultural and property entrepreneur, belonged to a family that had lived since the late fourteenth century in the Ponte quarter, where via dei Banchi was of high commercial value because it was home to the main banks. Construction on the building began before 1515, with the likely intention of dividing it into rental apartments. In 1519, the part of the facade between the right corner and the entrance must have already been completed, and work continued slowly until 1533, whereas almost all of the rest, including the courtyard and the lower part, was completed in the nineteenth century. Raphael worked out a plan between 1514 and 1515, although it is possible that he did not get involved until 1518, along with Giulio Romano, when work had already begun. In fact, the attribution to Raphael is, in this case, once again based on stylistic considerations. The grand facade overlooks a narrow street that only permits a foreshortened view. Like Palazzo Jacopo da Brescia, this facade also derives from the model of Bramante's Palazzo Caprini, here adapted to three levels and with an attic that was originally open in the manner of a gallery. Each floor is separated by cornices that protrude more than the vertical elements, emphasising the horizontality of the facade, which is further accentuated by a portal free of projecting elements. The rustication of the ground floor recalls that of the Palazzo Ducale in Urbino, the town where Raphael was born, but can also be seen in Rome in the Palazzo della Cancelleria. The upper floor has an abbreviated architectural order, which is to say with a capital that also serves as an architrave, alternating with sunk-in panels that frame the windows, creating an innovative spatial vibration of the facade. The same principle was also used for the uppermost floor, which is less decorated than the lower ones. The idea to give depth to a flat architectural surface not only lowered the cost of the decoration but was also optimal for a foreshortened view and reveals that Raphael thought about the architectural problem with the mentality of a painter.

FRANCESCO BENELLI

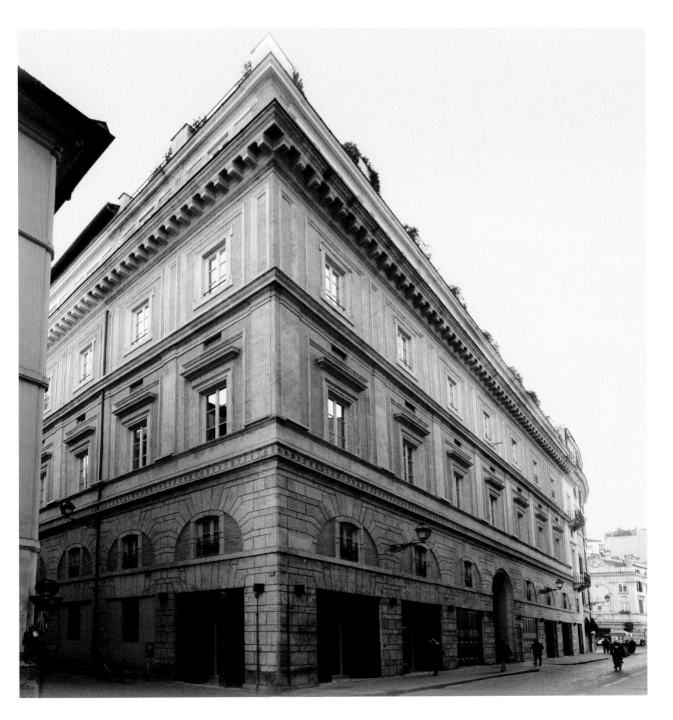

Villa Madama

1516–1518 (architectural plan)
Via di Villa Madama 250

In 1516, Leo X commissioned Raphael to design a vast suburban villa on the north-east slope of Monte Mario, near a pre-existing residence. Besides its favourable orographic features, the site offered a view from above of both the Milvian Bridge, a place of symbolic importance for Christianity, and the Vatican, thus adding strategic and symbolic value. The design was complete in 1518 and that same year the pope named as the official patron his cousin, the Cardinal Giulio de' Medici, who became directly involved in the planning and construction. What can be seen today of the villa is only part of the plan, later modified, described in the sheet Gabinetto Disegni e Stampe of the Uffizi 273 Ar by Giovanfrancesco da Sangallo: corresponding to that plan are a few spaces at street level, the foundations of the loggia on the garden and the base completed in the spring of 1519. That year, the plan was radically changed due to the clay-rich soil, which was unsuited to the grand terracing that had been planned. Antonio da Sangallo the Younger, an expert in structural issues, was called in to resolve the problem. The most important changes described in a letter that Raphael sent to Baldassarre Castiglione concerned the central rectangular courtyard, which was replaced with a circular one, and a new location for the outdoor theatre, which was now larger and set more deeply into the hill. Moreover, the first courtyard was lowered to the point of requiring the addition of a grand monumental stair to link it to the residential part. In 1520, the cardinal authorised another change to the project that, upon the death of Raphael, might have been revised by his pupil Giulio Romano.

In 1521, almost half of the residential block must have been completed, while work on the architectural decoration and statuary continued until 1527, the year of the Sack of Rome. From this construction phase, the rooms on the lower floor are assignable to Raphael, while the fishpond, *coenatio*, substructures, stairs, grand loggia on the garden and the fragment of the hemicycle resulted from the collaboration with Antonio dal Sangallo the Younger.

Giulio Romano headed the decoration, which involved various painters and stucco specialists. The plan for the garden was impressive and equally innovative, designed to extend over three large terraces in different shapes, never realised, below and to the south east of the villa, in order to link it to the Tiber.

Here, Raphael used an architectural language inspired by the great monuments of antiquity, but not yet fully detached from Bramante, as we can see in the large Ionic

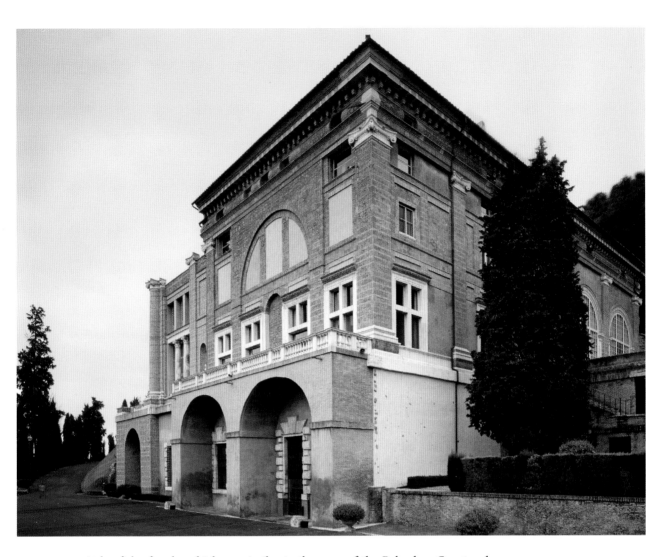

capitals of the facade, which are similar to the ones of the Belvedere Courtyard. The inclusion of cryptoporticus, terraces, gardens and nymphaea reveal precise knowledge of the ruins of ancient villas like Hadrian's Villa, which Raphael visited with his humanist friends Pietro Bembo, Baldassarre Castiglione, Andrea Navagero and Agostino Beazzano (pp. 46, 78–79) in 1516. The shape of the spaces of the loggia, and especially the large arched window supported by two pillars on the facade toward the valley, reveal strong interest in the imposing imperial baths, of which those types of opening were characteristic. While study of ancient ruins had provided Raphael with a vocabulary of forms and structures, the functions of the various interior spaces, which included baths, a library, the *coenatio*, a triclinium, a theatre and a fishpond, derived from knowledge of ancient literary sources, such as Pliny and Vitruvius.

FRANCESCO BENELLI

The project for St Peter and other buildings, destroyed or not built

After 1514, the year in which he became Papal Architect, Raphael also took on the role of superintendent for the maintenance and urban renewal of the entire city of Rome. He devoted himself to New St Peter's even before Bramante's death, in 1513, when the parts of the transept, choir and dome lantern that had already been built could no longer be changed. We know of two projects that were not realised. The first, developed when he was still working alongside Giuliano da Sangallo and Fra Giocondo, was published in Sebastiano Serlio's *Terzo libro delle antiquità di Roma* of 1540. The second, evidence for which survives in the Codex Mellon of New York (ff. 71v–72r), is striking for its notable compositional coherence, putting all of the parts of the building into harmonious relation through the compact use of the architectural order. Raphael made further changes to the plan between 1518 and 1519, resulting from a probable collaboration with Antonio da Sangallo the Younger.

In 1518, Giovanbattista Branconio dell'Aquila, camerarius to Leo X and later executor of Raphael's will, who conceived the *Visitation* (Madrid, Museo del Prado) for him, commissioned him to design his own house, located at the west end of via Alessandrina in Borgo, completed in about 1520 and demolished in 1660. Richly decorated with motifs taken from the Pantheon and the exedra of Trajan's Market, the facade was innovative for the absence of rustication on the ground floor, which was replaced with Doric half columns framing the shops' arcades.

In 1519–1520, Raphael decided to build himself a house consonant with his stature, located in via Giulia near the church of San Giovanni dei Fiorentini (in 1519, he had entered the competition announced by Leo X for the design of the church). The plan for the house, which remained unbuilt due to Raphael's death, is distinguished for its elegant forms and includes a porticoed courtyard complete with niches for his collection of ancient statues, which still remains only partially reconstructed.

FRANCESCO BENELLI

Anonymous, section drawing of Raphael's plan for St Peter's of 1513. New York, Pierpont Morgan Library, Codex Mellon, ff. 71v–72r

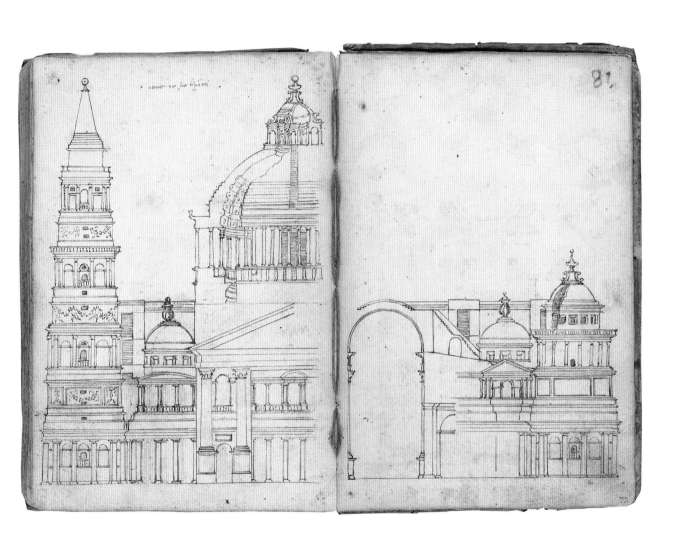

santi por fra [...]

The Study of Ancient Architecture and the Letter to Leo X

Raphael began his study of ancient sources, understood as both stone monuments and written documents, in at least 1508. In addition to the survey drawings of ancient Roman buildings and the celebrated view of the interior of the Pantheon (Uffizi 164 Ar, 1506–1508; **fig. 8**), after 1515 he entrusted a vernacular translation of Vitruvius's *De Architectura* to the humanist Fabio Calvo and, in 1516, he began to compose the famous Letter to Leo X, which he wrote in collaboration with Baldassarre Castiglione and of which we have three manuscript versions.

Before then, the printed version of Vitruvius's treatise was in Latin, rendering it difficult to understand. A vernacular translation would have been very convenient for an ambitious, cultivated architect like Raphael, working in a context, that of Leo X's Rome, in which mastery of the theory of ancient architecture had become a powerful cultural tool for triumphing in close competition with rival artists and architects. Calvo's translation of Vitruvius includes notes that reflect Raphael's knowledge and ideas: though not without errors, they stand as true commentary and reveal an excellent familiarity with Roman topography and mastery of the technical language in use during those years.

This translation was undoubtedly used by Raphael for the letter that he wrote with Castiglione to Leo X, the aim of which was to explain the reasons, methods and strategies for his project for an ambitious map reconstructing ancient Rome and accompanied by a text, which the pope himself had asked him to write. The final result, never realised, was to be a book in which, besides the map, the ancient buildings would be individually described as well as illustrated and reconstructed with plan, elevation and section drawings, the same structure that Sebastiano Serlio employed in his *Terzo libro delle antiquità di Roma* (Venice 1540). The text of the letter provides extraordinary evidence of Raphael's knowledge of architectural history, construction and surveying techniques, planning methods, architectural styles and ancient decoration, stressing with exceptional awareness the importance of the preservation and study of ancient ruins as *exemplum* fundamental for modern architects.

These were ideas that Raphael developed in his role as architect of St Peter's, held since 1514, and then, starting in 1515, that of superintendent of all marbles and stones found in Roman territory (the pope appointed him *praefectus marmorum et lapidum omnium*), in which his contemporaries already glimpsed the root of the

project later presented in the Letter to Leo X. In these roles, he was put in charge of the excavation materials to be used for building the basilica and given the further task of examining all of the fragments containing inscriptions so that they would not be destroyed, as they were useful for expanding knowledge of the ancient language. These experiences, and most importantly Raphael's association with humanists such as the men-of-letters Pietro Bembo and Baldassarre Castiglione, his friends and admirers since the Urbino years, as well as the architect and expert in ancient architecture Giovanni Giocondo, helped shape the Letter to Leo X, written with Castiglione, which is to be understood against the background of reflection on the relationship that moderns ought to have with the legacy of the ancients, reflection that dominated the Leonine papacy.

The letter documents not only Raphael's profound knowledge of ancient architectural styles and decorations, but also the rise of an acute awareness of the urgent need to protect monumental heritage—a theme that would become the subject of public reflection and then legislation centuries later—and shows that the need to preserve ancient monuments was coming at that time from the destruction inherent to new construction. The centuries-old practice of using materials from ancient Rome to build modern Rome must have seemed like an open contradiction to these mindful humanists, Raphael first and foremost: it was the same contradiction revealed in the letter when he denounces as destroyers of antiquities not only the barbarians but also the popes who preceded Leo X: "How many Pontiffs, Holy Father—men who held the same office as Your Holiness but who had neither your wisdom nor your qualities or magnanimity—how many of these Pontiffs, I say again, allowed ancient temples, statues, arches and other buildings—the glory of their founders—to fall prey to ruin and spoliation? How many of them allowed the excavation of the foundations simply to get at some pozzalana, such that in a very short time those buildings collapsed? What quantity of mortar was made from the statues and other ornaments of the ancients? I would go so far as to say that this entirely new Rome that can be seen today—grand, beautiful and marvellously ornamented with palaces, churches and other buildings though it may be—is built using mortar made from ancient marbles."

Now more than then, the need for protection emerges from awareness of this contradiction between the need to lead the new and the importance of preserving the old: that Raphael was the first to stress this, and with such intelligence and passion, highlights his extraordinary modernity and draws him even nearer to us.

FRANCESCO BENELLI AND SILVIA GINZBURG

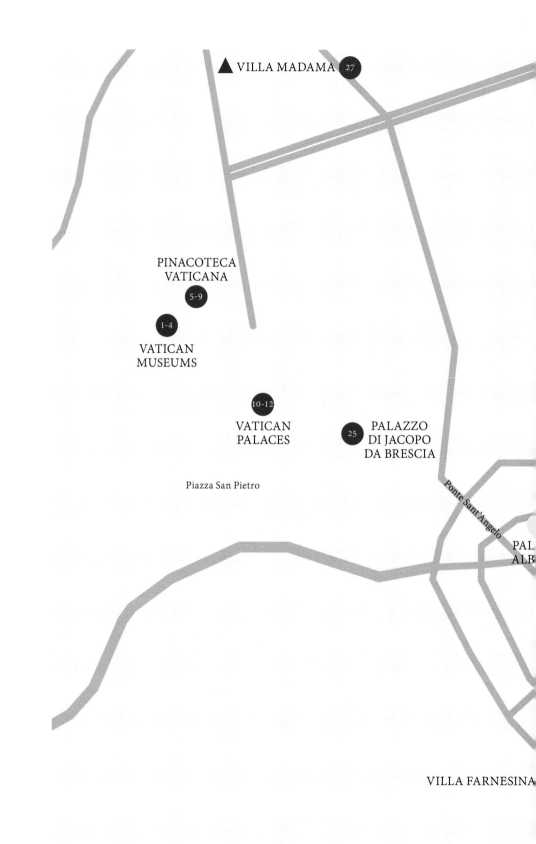

▲ VILLA MADAMA 27

PINACOTECA
VATICANA
5-9

1-4

VATICAN
MUSEUMS

10-12

VATICAN
PALACES

25 PALAZZO
DI JACOPO
DA BRESCIA

Piazza San Pietro

Ponte Sant'Angelo

PAL
ALB

VILLA FARNESINA

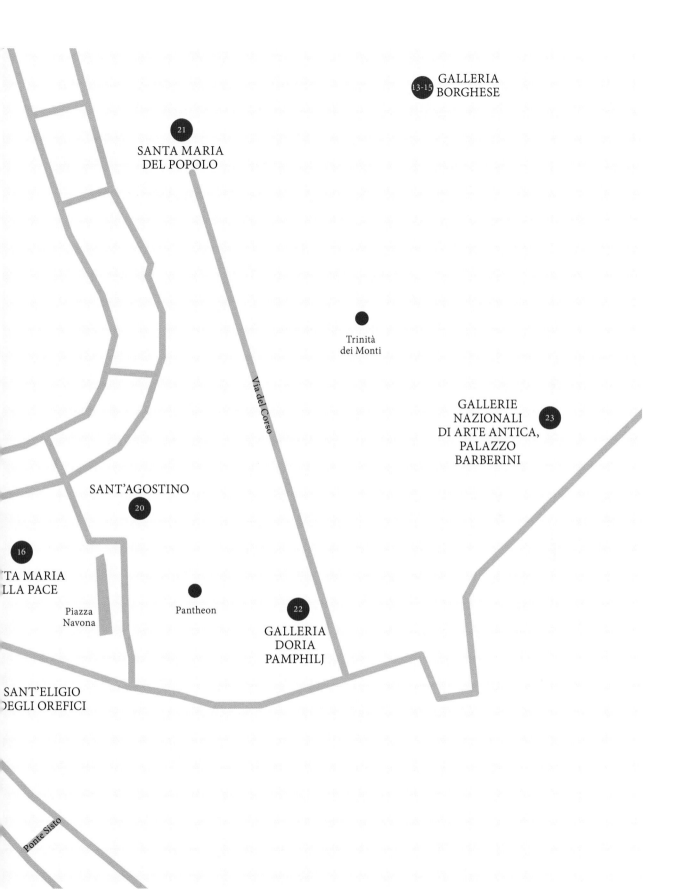

GALLERIA
BORGHESE
13-15

21
SANTA MARIA
DEL POPOLO

Trinità
dei Monti

GALLERIE
NAZIONALI
DI ARTE ANTICA,
PALAZZO
BARBERINI
23

Via del Corso

SANT'AGOSTINO
20

16
TA MARIA
LLA PACE

Piazza
Navona

Pantheon

22
GALLERIA
DORIA
PAMPHILJ

SANT'ELIGIO
DEGLI OREFICI

Ponte Sisto

cover
Galatea, Villa Farnesina

page 2
Mass of Bolsena, detail
Vatican Museums, Stanza di Eliodoro

page 4
Transport of Christ to the Sepulchre, detail
Galleria Borghese

RAFFAELLO
1520–2020

Art director
Paola Gallerani

Designer
Chiara Bosio

Translator
Sarah Elizabeth Cree for NTL, Florence

Color separation
Premani srl, Pantigliate (Milano)

Printing
Stabilimento Tipolitografico Ugo Quintily SpA, Rome

Press Office
Luana Solla

isbn: 978-88-3367-101-7

© Officina Libraria, Rome, June 2020

Printed in Italy
Ex Officina Libraria Jellinek et Gallerani

officinalibraria.net Officina.Libraria officinalibraria